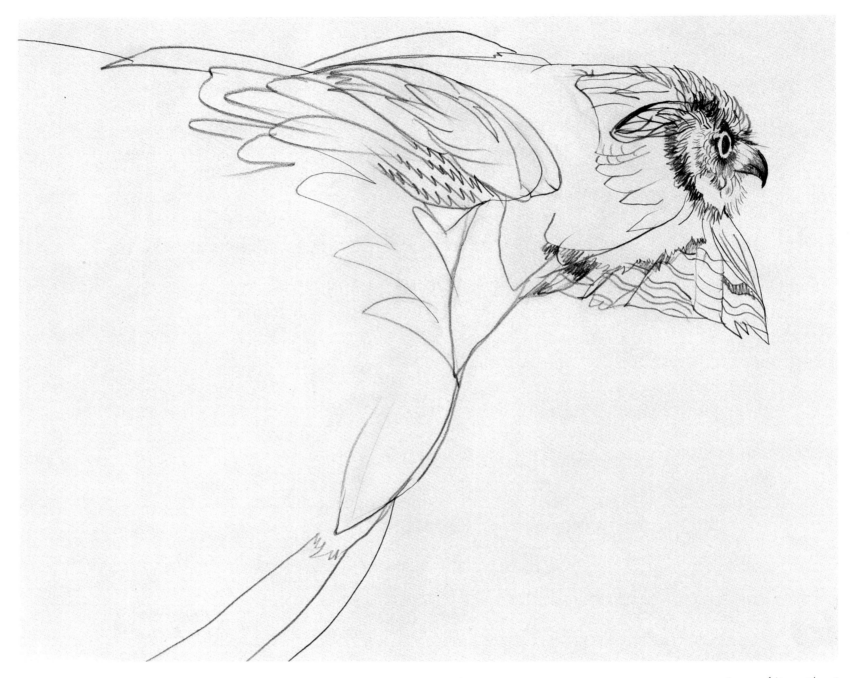

FLYING OWL II *1981, graphite, 14½ × 18*

BETH VAN HOESEN CREATURES

The Art of Seeing Animals

by Beth Van Hoesen

Prints, drawings, and watercolors

Foreword by Evan Connell

A YOLLA BOLLY PRESS BOOK PUBLISHED BY

Chronicle Books San Francisco

To all the animals in this book,
who have enriched my life, taught me patience,
and brought me much joy.

A YOLLA BOLLY PRESS BOOK
This book was produced in association with the publisher by Carolyn and James Robertson at The Yolla Bolly Press, Covelo, California 95428. Staff: Barbara Youngblood, Diana Fairbanks.

The producers express their deep appreciation to Mark Adams, without whose care, judgment, and unfailing good humor this book would not have been possible.

Reproductions in this book are from photographs taken by Lee Fatherree. Photographs of the artist printing *Sally* were taken by Diana Crane.

Type for this book was set by Wilsted & Taylor, Oakland, California.

LIBRARY OF CONGRESS CATALOGING-IN-PUBLICATION DATA
Van Hoesen, Beth, 1926–
 Creatures: the art of seeing animals.
 1. Van Hoesen, Beth, 1926– —Sources. 2. Animals in art.
3. Artists' preparatory studies. I. Title.
N6537.V28A4 1987 760'.092'4 86–23595

CHRONICLE BOOKS
San Francisco, CA

ISBN: 0–87701–464–7 (pbk.)
ISBN: 0–87701–470–1

10 9 8 7 6 5 4 3 2 1

Printed by Dai Nippon Printing Co., Ltd., Tokyo, Japan.

List of Plates

Foreword

IN A DISCUSSION of Holbein's regal portraits—Sir Thomas More, Henry VIII, Lady Elyot, Prince Edward of Wales, Charles de Solier—Helen Langdon remarks that Holbein's approach was objective; he concentrated on the individuality of the sitters, delineating them just as they were at a particular moment. I think the same might be said of Beth Van Hoesen's less-exalted subjects. Look at the pelican, the irritated cats, those rapacious falcon chicks, the prodigious black-and-white cow stunned by its own bulk—as though wondering how such a modest animal as itself came to be trapped in such a body. Consider the brown rat, the self-conscious China geese, a dog named Feather trying to unravel the mystery of humans, an altogether gross hog, an angry panther.

I am not surprised by this exactitude. Forty years ago Beth Van Hoesen and I were art students at Stanford. We attended at least one painting class together, maybe two, and it did not take me long to realize that she was the competition. The work of one other student did impress me—a girl who painted with such appalling sweetness that she may have diluted the oils with maple syrup instead of turpentine. As for the rest, they are long forgotten. But I liked what Beth was doing so much that I persuaded her to sell me one off the easel—unfinished, quite obviously unfinished. As a matter of fact she had just begun when I wandered over, uninvited, gazed at the sketch for a while, and proposed buying it. I don't remember what she said but I think she was pleased, maybe startled. Anyway, she agreed. I inked the date—1948—on the frame.

I still have this tentatively colored outline, the first work she ever sold, and I am glad I had enough foresight to insist that she sign it. I can prove its authenticity—if anyone doubts me—because a copy of her elegant 1972 book, *A Collection of Wonderful Things*, has been inscribed: "With gratitude for buying the first painting . . ."

We have talked about this transaction a couple of times since our days at Stanford, and not long ago Beth told me that several girls in the class became very inquisitive, suspecting there might have been more to such a remarkable purchase than met the eye.

Since 1948 the number of Van Hoesen collectors has increased appreciably, and without doubt there will be more because she gets better all the time.

Now, the growth of an artist is not an inevitable process like the growth of a tree; it is a consequence of that indescribable, indecipherable faculty called intuition, and of methodical nine-to-five application, day after day, week after week, year after year, decade after decade, without much time off. Indeed with no time off, because the eye of a professional artist doesn't relax. There is no such thing as a holiday. The artist might decide to spend three weeks frolicking on the beach, but the eye will not stop reporting, nor will the diligent brain stop coordinating information, so that eventually some of what was noticed will reappear—in the angle of a cormorant's wing against the wind, let's say, or in the bulk of a harbor seal.

According to a biographical note in *A Collection of Wonderful Things*, it never occurred to Beth Van Hoesen that she was *not* an artist; and right here, I suspect, is the point at which the natural-born artist may be identified, distinguished from the amateur or dilettante. In other words, all sorts of people take up drawing and painting and gradually

improve while wondering about the degree of their talent, wondering if it actually is somehow possible to *become* an artist. The innate artist doesn't think like that.

Giotto, for example, never doubted his destiny. We learn from Vasari's *Lives of the Artists* how the great Cimabue on his way from Florence to Vespignano came across a shepherd boy scratching pictures on a slab of rock: "Cimabue stopped in astonishment to watch him, and then he asked the boy whether he would like to come and live with him. Giotto answered that if his father agreed he would love to do so. . . ." I think it fair to assume that Giotto never considered the possibility or impossibility of becoming an artist. He simply *was*.

I also think that what stopped Cimabue flat-footed on the road to Vespignano was more than the extraordinary skill of a shepherd boy. Cimabue observed something else. Picasso remarked during a conversation with Christian Zervos that a picture is not determined beforehand; instead, while a picture is being made, "it follows the mobility of thought." I have no trouble visualizing Cimabue transfixed by the sight of a young shepherd drawing without premeditation.

The truth of Picasso's argument can be established if you look long enough and closely enough at the work of almost any artist. You will notice this in several Van Hoesen creatures. I perceive—at least I believe I do—how the brush or pencil or burin was guided by the mobility of her thought. Look at the embryonic Monterey otter. I cannot believe she decided upon such a symbolic shape ahead of time. Look at the terrible hand of the mole, at the Oriental pattern of tiny pigs that remind the printer of cocktail sausages, at the manatee in turquoise water—a pallid myth from another realm.

Or do I imagine? A picture lives through him who looks at it, Picasso said.

I see in the great horned owl Buster a genetic fearlessness, a representative of Night without mercy, implacable as a Haida totem pole. Yet that isn't quite the owl Van Hoesen observed, because she states in her commentary that Buster made no attempt to stare her down and often looked aside. He was, so to speak, a diffident owl. I defer to the fact that she got acquainted with him while I did not. Nevertheless,

as this owl exists on paper, he embodies the spirit of murderous nocturnal business.

Van Hoesen's lugubrious brown bear with a yellow eye and a nose that has sniffed innumerable unfamiliar objects— I believe his mind is slowly exploring very distant, dusty thoughts. Ursine thoughts. What might they be? Let us consult a medieval bestiarist. Listen. If Ursus falls sick—if, say, he has eaten the poisonous mandrake—he knows enough to cure himself by devouring ants. So that might be what the brown bear is thinking. However, the bestiarist continues, of any food on earth Ursus chooses honey and will spend much time in the forest looking for the hives of bees with their succulent combs. So that could be what travels through this particular bear's mind, a vision of succulent honeycombs. All we know for certain is that he is an individual, unique and private.

What does the bestiarist say about eagles? They are noted and thus named—*egle, aigle, aquila*—for the marvelous acuteness of their eyes. Aquila flies so high into the air that he grows invisible to man, yet he is able to espy little fishes in the ocean and swoop down like a thunderbolt to carry them off. Look you, now, upon the lordly profile of *Ichi* with his beak hooked in contempt or bitterness. Behold him also while he listens to airplanes.

All of which is to say that as you turn through this volume you will find a modern bestiary, not of generic animals but of singular creatures—specific eagles, bears, dogs, rabbits, cats, pelicans, bulls, and roosters.

What accounts for such a scrupulously recorded menagerie? Observation and intuition, yes. Decades of experience, true. Yet an aura of magic persists. Aldous Huxley, reflecting on a work by Goya, *Dos de Mayo*, commented that the artist was speaking his native language, "and he is therefore able to express what he wants to say with the maximum force and clarity." Maybe that comes close, if words can describe a graphic talent. An artist who produces substantial work is an artist who has spoken his native language, who has been faithful to his or her conviction, who has not run down unnumbered streets in search of popularity.

The Anglo-Irish novelist Joyce Cary remembered a day when he was sixteen years old, vacationing in France, and

went to get a basket of eggs from a farmhouse where a destitute old painter lived with his exhausted wife. This painter had been quite successful; year after year his work hung in the Academy. But fashions change, and all at once the Academy began rejecting him. Cary discovered him among the hollyhocks in his garden, where he was comparing live flowers with his latest floral painting—which had been rejected. He asked Cary to look at his painting of hollyhocks, and he pointed out some of the very best touches. He was in despair, baffled and hurt. He said of the academicians: "They don't care for beauty anymore. They hate it. They only want this new rubbish. The world has gone mad—it despises beauty and only wants ugliness."

Then, to Cary's great surprise and discomfort, the old painter began to cry. Cary had never seen a man of that age weeping and did not know how to respond, so he murmured a few words of condolence and escaped as soon as possible. Changing fashion had destroyed the old man financially, which was bad enough; yet even more tragic was the fact that this man's life no longer held any significance. He had devoted himself to acquiring and polishing a skill that was at last unappreciated.

Where is the fault? Does it lie with a capricious world or in an old man's stubborn allegiance to hollyhocks?

How does an artist avoid this ignoble fate? Does he calculate graphic trends, exemplify the newest, struggle heroically to be *au courant*, never look back? The artist clever enough or ambitious enough to practice this will not likely find himself obligated to feed chickens at some late hour, his work dismissed, his life a crushed eggshell.

It is hard to imagine more profound despair than the old man in the garden must have felt as he continued unsuccessfully to paint the one thing he could paint without deceit. Yet he had been faithful to his nature; for better or worse, he had not equivocated. Some people are like that, and very often they come to grief, the world being what it is. Beth Van Hoesen, so far as I know, is one of those people. I have watched her progress since 1948, and if she ever once changed course in an effort to be fashionable, I am not aware of it. Happily, her resolute nature has not led to a collapsing farmhouse with an exhausted spouse and a studio full of rejected pictures.

Picasso offered another instructive idea. He said that at the beginning of each picture someone seems to be assisting him, but toward the end he feels alone. This realization—that finally he must be alone—no doubt helps to explain his characteristic style, or styles. You are not apt to mistake anything Picasso has drawn or painted for the work of somebody else. This probably is true of all creative artists, much less so in the case of those who imitate. What this means is that when a work of art is original, the signature may be superfluous, and when you have looked at enough Van Hoesen drawings and paintings you do not need to look for a signature.

Introduction

I'VE ALWAYS DRAWN pictures. Before I was seven, I lived on an apple orchard my family owned in Idaho. There were lots of things to draw there, but I drew only people—the children at the one-room schoolhouse or the apple pickers at work—many little people all over the page. After we left Idaho, I lived in many different places. In Greenwich, Connecticut, I drew the chauffeurs waiting for the commuter train, and in New York, I drew shoppers going through the racks of clothes at Macy's. When we lived in a hotel in Walla Walla, Washington, I drew people sitting in the lobby, and in Long Beach, California, people strolling and the barkers on the Pike. In all the many schools I attended, there were few art classes. When I was recovering from a long illness and had to stay inside, I drew from pictures in books and magazines. My first art lesson using oils was given to me by a California desert painter who lived next door. He had me copy a reproduction of a portrait of Walt Whitman by Thomas Eakins. When I look back, I realize that I learned a great deal from copying—studying a painter by looking at each brush stroke. One of my favorites, Degas, also learned from copying in museums.

I don't remember making a decision to be an artist. I just *was* one. Since I was mostly self-taught, I felt the need to learn more skills and wanted to go to Black Mountain College to learn of the art of the time. However, my parents wanted me to go to a four-year college, so I went to Stanford.

The art department there was small and quite academic at that time. I finished every art course offered in just two years. I learned more about seeing from Victor Arnautoff—"Look at zee neck, eet ees not a toob"—and Dan Mendelowitz—"That's swell." Summers I attended the California School of Fine Arts, where I got big doses of the art of my time from Clyfford Still and others. I also spent six months at the Escuela Esmeralda in Mexico, where I learned still more ways of seeing—"*no solamente con sus ojos, pero con su corazón*" (not only with your eyes, but with your heart). Returning to Stanford, I worked on independent study, which included building a wall in order to paint a fresco. I also drew cartoons for the *Stanford Daily*. I didn't learn to type, play bridge or tennis—I needed that time for my work. In one of my art classes, I met a young writer. Evan Connell drew very well, especially in the figure drawing classes, and now after so many years and books and honors, he has written the foreword to this book.

For two years in Europe, I haunted the museums, drew at the art schools, and painted portraits of Americans for a subsistence living. I was still mostly interested in painting and drawing *people*. My heroes in art were all from the past.

Returning to San Francisco in the early 1950s, I continued to paint portraits, but they were mostly of children. Mothers usually dressed their daughters in smocked dresses. It was all the smocking that decided me against portraiture. I have never since accepted a portrait commission (not even of a dog) although I draw many people and animals.

With the idea of learning to use my art to support myself, I returned to the California School of Fine Arts for a class in illustration, which I found I could not do: making up imaginary situations with stylized people was not for me. I must have seemed like a misfit when I entered David Park's paint-

ing class, sat up close to the model, and took out my little bottles of boiled oil, my hand-ground paints, and my small wood panel, gesso-grounded and sandpapered, to paint on. David Park's charm and wit lured me to the back of the room, where I painted spaces between the arms and cut off the heads at the forehead. In no time at all, my painting was just like my teacher's. He thought I was very good!

During those years, I also worked at part-time jobs that required very little skill, such as answering the phone for Arthur Murray's radio commercials where listeners could guess the name of a tune and get a free dance lesson. I also worked as a hostess at a German restaurant near the little rented house where I lived on Telegraph Hill. Occasionally I sold the pen-and-ink sketches of houses, gardens, and people that I had done in Paris. One day a friend brought over an artist who had agreed to help him choose drawings for his apartment. Mark Adams was introduced as the artist who had painted the abstract murals in a popular little bar that he had named the hungry i. He, too, had decided not to teach art and was working at the American Can Company as a graveyard-shift timekeeper—and, of great importance at the time, he had studied with Hans Hofmann in New York. The previous classes at CSFA and my struggle with abstract expressionism had left many questions in my mind, and I was planning to go to New York to hear firsthand from the best teacher of the time, Hans Hofmann. Mark said, "Why go to New York? I can teach you what he taught me." During several lessons, he answered my persistent Why? and What do you mean "plastic"? To my amazement, however, he did not share my enthusiasm for Rembrandt; in fact, he felt that Rembrandt just put a head in the middle of a dark canvas—no energized space around it! It was only after years of marriage, of visiting museums together here and in Europe, of searching to understand Mark's choices, that I began to feel what all the fuss among my peers was about. It became relatively simple once I started feeling the relationship of color and space.

Drawing from reality, my work became intuitive and interpretive. After I had made a drawing, I would often spend a long time perfecting the relationship of object to background. Even an eighth of an inch can make a difference.

Mark now likes Rembrandt and understands what I mean when I say, "That painting is alive."

Since I had exhibited before we were married, I decided to keep my maiden name for my work. I often wonder how it would have been if I had signed "Mrs. Mark Adams." Mark continued his large architectural works in tapestry and stained glass, and I branched into intaglio printmaking, small works in black and white. After many years of looking for working space, we finally found a firehouse built in 1909 to work and live in. Since San Francisco did not have many galleries in the fifties and sixties, we showed our work in the three museums and slowly began to live on what we earned from selling our work.

In the 1960s I began to use color in my drawings and prints. Working with watercolor and colored pencil in preliminary sketches, I found that I liked this combination as a mixed media for finished work.

I don't remember when I began drawing plants—vegetables as well as flowers. I saw each leaf as different from the other; each stem and root was a new shape. It became my main interest for a time, and collectors began to think of me as a "flower artist."

Although I had drawn animals before, it wasn't until four years ago that I decided to do portraits of animals, to try to bring out some of their individuality. I started with pet rodents, farm animals, dogs, and cats. Then came a few birds, then wild animals. I keep meeting new ones I like, so now I am thought of as an "animal artist."

In addition to my particular interest of the moment, I still draw from the nude model. Once a week for the last ten years, Mark and I have been joined in our firehouse studio by Theophilus Brown, Wayne Thiebaud, and, until his recent death, Gordon Cook in a four-hour drawing session with a live model. Drawing from reality demands an absorbing concentration and takes you away from a self-conscious arbitrary style into work that is really your own. Even though each of us may be doing very different kinds of artwork the rest of the time, these sessions keep our observations sharpened and our hands in practice. All of us agree that drawing is basic to our work. And we all are still learning.

BETH VAN HOESEN CREATURES

Bobcat

A bobcat named Rufus lived at the Animal Research Center at the San Francisco zoo. While I was drawing Ishi, the bald eagle, I often saw him nearby. Later I went over to watch him more closely and decided that I wanted to draw him. Much of the time he sat very still at the far end of his cage, watching something intently. He was alert, and his ears stood straight up. I finally saw that he was staring at some water buffalo in a nearby field. (Sometimes when I am drawing, the animal will sit very still; and then *just* before I'm finished, it will get up and change positions.) I sat very close to Rufus's cage because I wanted to see all his whiskers and hairs. His keeper warned me not to sit that close because Rufus sometimes sprayed visitors, and if he did, it would take weeks to get rid of the odor! I became very fond of this cat even though I couldn't make eye contact with him. He seemed to look right through me with that wild stare.

Two owners of this print have told me that when they first hung the *Bobcat*, their dogs would stare or bark at it.

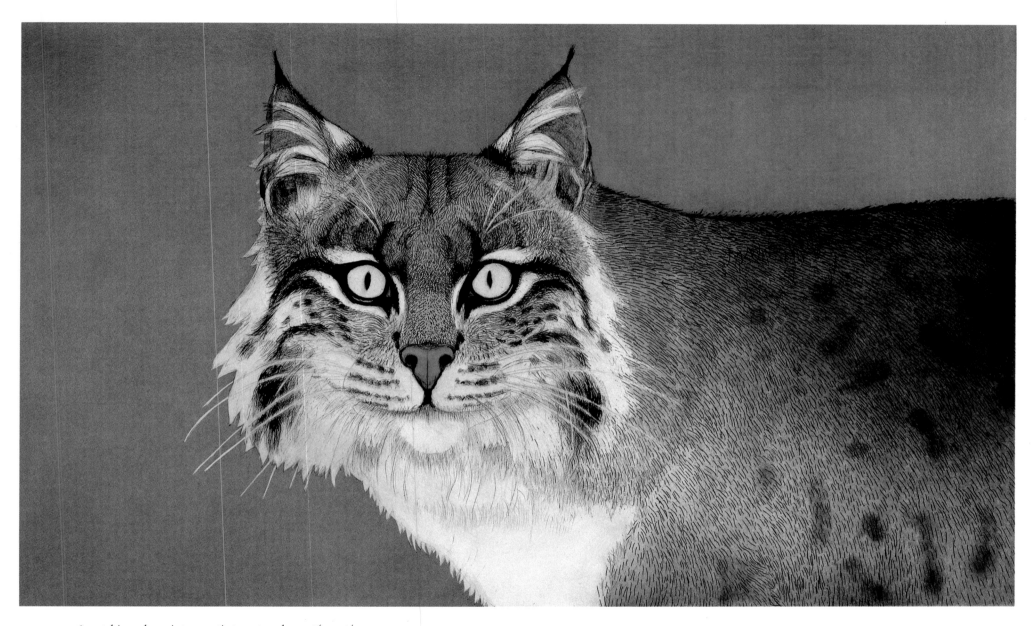

BOBCAT *1984, etching, drypoint, aquatint, watercolor, 11¾ × 19¼*

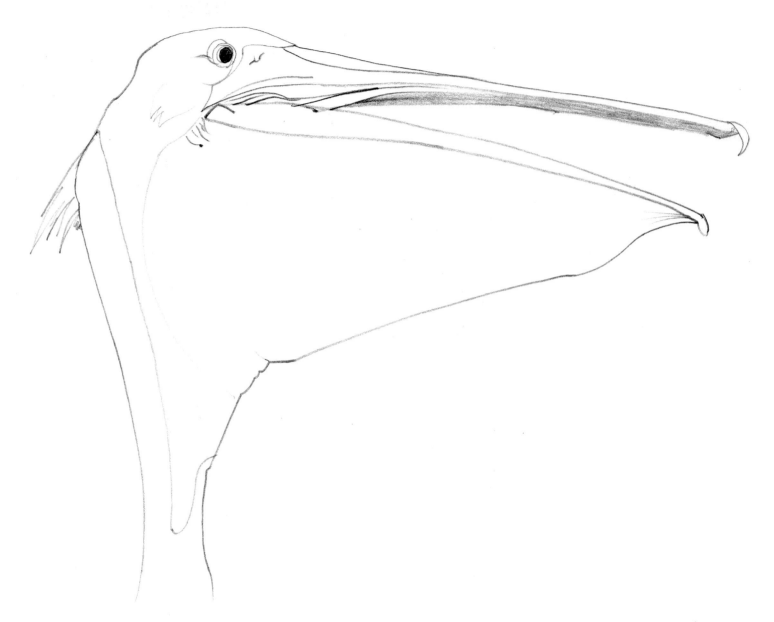

PELICAN *1981, graphite, 14×17*

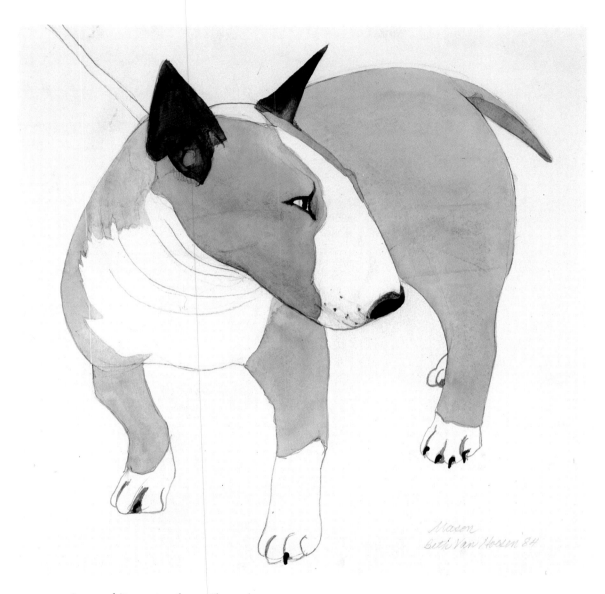

MASON *1984, graphite, watercolor, 12¹/₂ × 12¹/₂*

Suffolk Sheep

In my search to find a large bull to draw, I went to the 4-H Club section at the county fairgrounds. There were some bulls there, but I didn't find one I liked. As I wandered around, I looked out behind the cow barn and saw a black-headed sheep tied to a platform where the animals are combed before they're shown. I was really taken by this sheep because she was so elegant, with a head like a Nubian goat's.

As I drew the sheep, she kept looking at me out of the corner of her eye. A girl was combing the sheep's wool. A smaller girl, sitting on a bench nearby, said, "Oh look, she's drawing Natasha." I wrote down the name.

Before I was finished, they had to take Natasha inside for judging. I went home and worked on the drawing. I had captured the personality, but the drawing needed a little more definition of form in the cheekbone area. I called the fairgrounds, but, alas, Natasha had already been sold to a butcher.

I got in touch with the owner of the sheep to see if Natasha had any brothers or sisters. I identified the sheep by number, and the young girl said the sheep was the last one of the family since its mother had died. I asked why the cut of Natasha's neck, from the black woolly part into the white part, was so different from the other sheep. "That's not a regular cut," she said. "My mother invented it; it's called a V-neck-sweater cut." I also discovered that Natasha wasn't the sheep's name at all, but the name of the girl's sister, whom she thought I was drawing. The sheep's name was Baby. I thought she was too old and too dignified to be called Baby.

Later, at another fair, I found rooms full of black-faced Suffolk sheep. None had the V-neck-sweater cut, nor did any of them look like Natasha. But I was able to get the bone structure from one of them; then I went home and finished *Suffolk Sheep*.

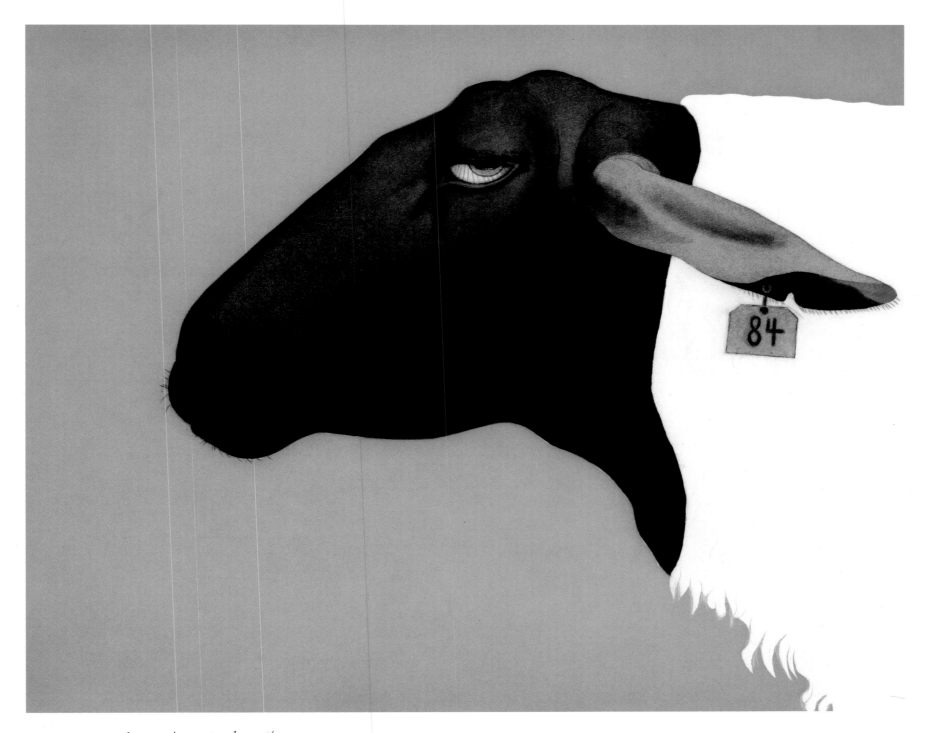

SUFFOLK SHEEP *1982, aquatint, watercolor, 13¾×17*

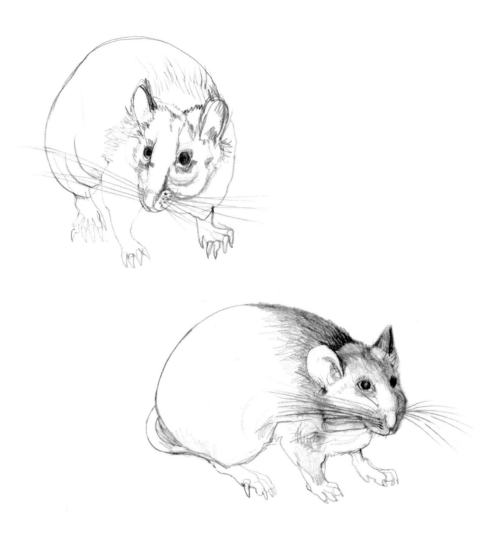

BROWN RAT STUDY *1981, graphite, 16 × 13¼*

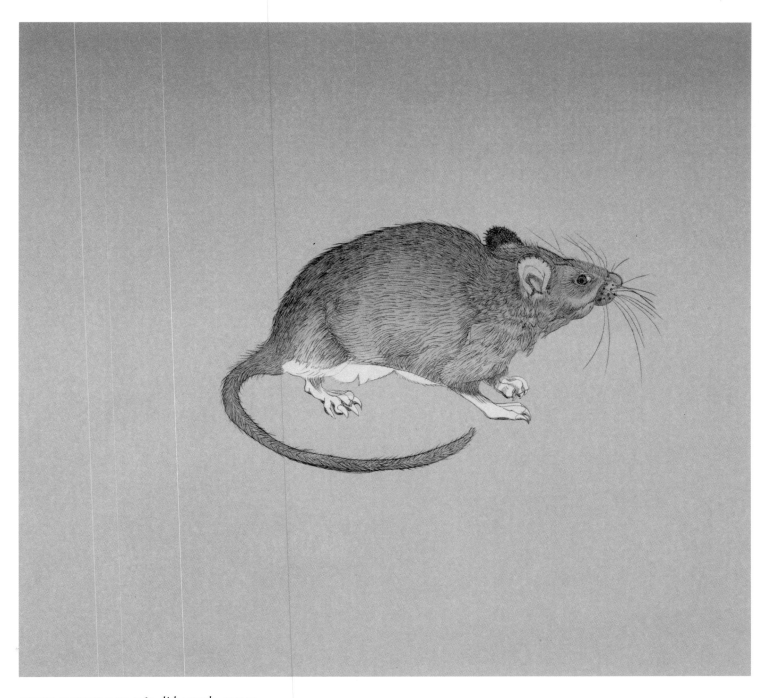

OLIVIA BROWN RAT *1981, lithograph, 11 × 12*

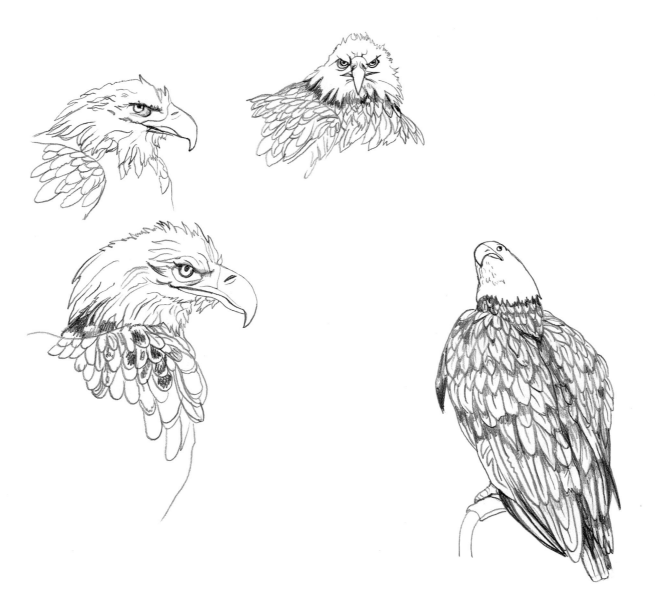

ICHI SKETCHES #6 (ICHI LISTENING TO AN AIRPLANE) *1983, graphite, 14¼×16¾*

12

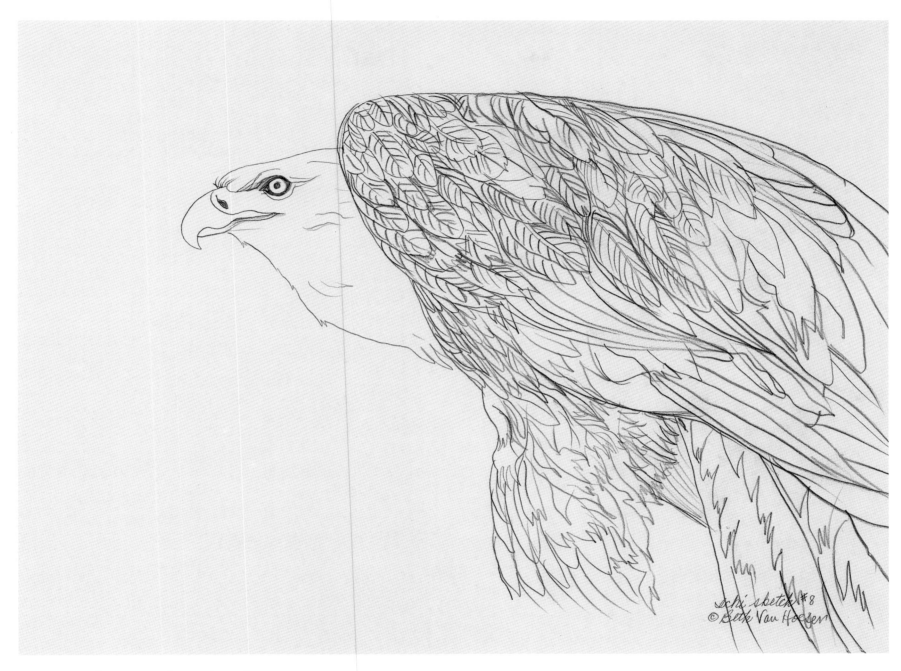

ICHI SKETCH #8 *1983, graphite, 15¼ × 20¾*

Ichi

I had wanted to draw a bald eagle for a long time, but hadn't been able to find one. Finally someone told me there was one behind the children's zoo. I called for permission to draw there and took my art materials to the Animal Research Center. The birds and animals who live there are classified as "imprinted" and cannot be released in the wild. They either have injuries or, as pets, relate to humans more than to their own species. They are well cared for and studied by professionals and trained volunteers.

This bald eagle was named after the last member of a Native American tribe of California. Ishi was brought from his house and tethered to his perch. The tether was four feet long, which allowed circular movement. He often jumped off his perch and spread his huge wings. It was exciting to be so close to this magnificent bird, and after several days he seemed quite gentle. It was only when his keeper put on heavy gloves, in preparation for Ishi's flying lesson, and handled him with great respect, that I became aware that he was a wild predator.

I named the print *Ichi*, but then I found out that it is spelled "Ishi." I also found out that "he" was a "she."

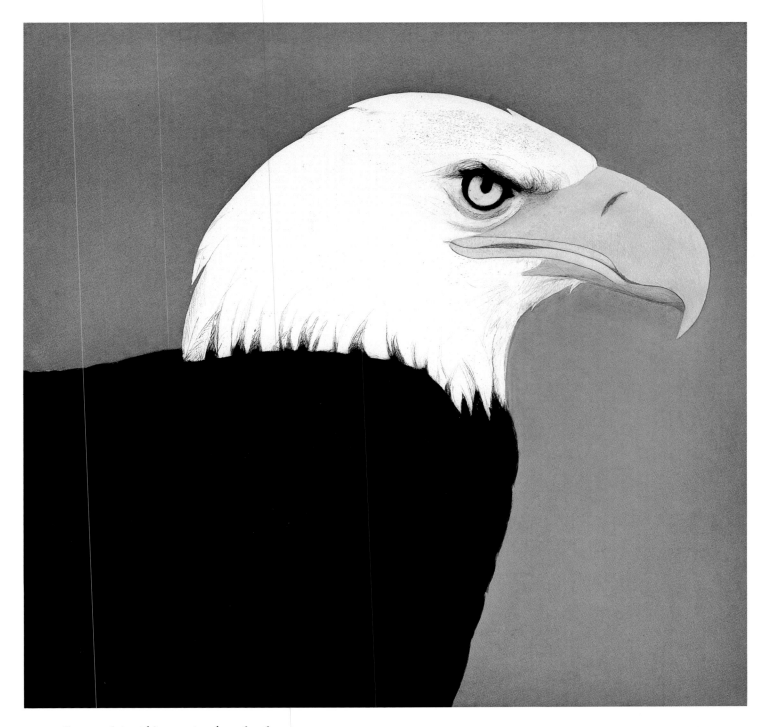

ICHI *1985, aquatint, etching, watercolor, 16×16*

Puff

When I go to an animal show, I walk around and look at all the animals. By the second time around, there is usually one that catches my eye or has a little more personality than the others. Then I ask the owner if I may sit in front of the cage and draw. At a small cat show at the Hall of Flowers in Golden Gate Park, I finally chose this Persian cat with long fluffy hair, which I thought would make a good drypoint. I have always been intrigued by all of the glorious fur surrounding the mean little face. He doesn't look that way because he is cross; his bone structure makes him look that way. This particular cat—Puff 'n' Stuff (just the beginning of a long pedigreed name)—shared his cage with another Persian. When I asked the owner if I could draw Puff, she wanted me to draw the other cat because it was a "better" cat. I explained that Puff appealed to me because of his personality, not because he might win a ribbon. She was not pleased at all, but let me sit by the cage to draw until I was almost finished. At least I had the head finished. I hadn't had time to draw the body, and I wanted to check the drawing again. By then the cat show was over and the woman wanted to leave right away. I asked if I could come to her house to complete the drawing. Usually owners are pleased to have their pets drawn, but not this one. I suggested other places where we could meet, but again she refused. She finally said that if I wanted to see Puff again, I could come to the cat show the following year! I decided that I didn't want to wait another year to finish the drawing. At least I had captured the expression I wanted on the face, so I did the print without the rest of Puff.

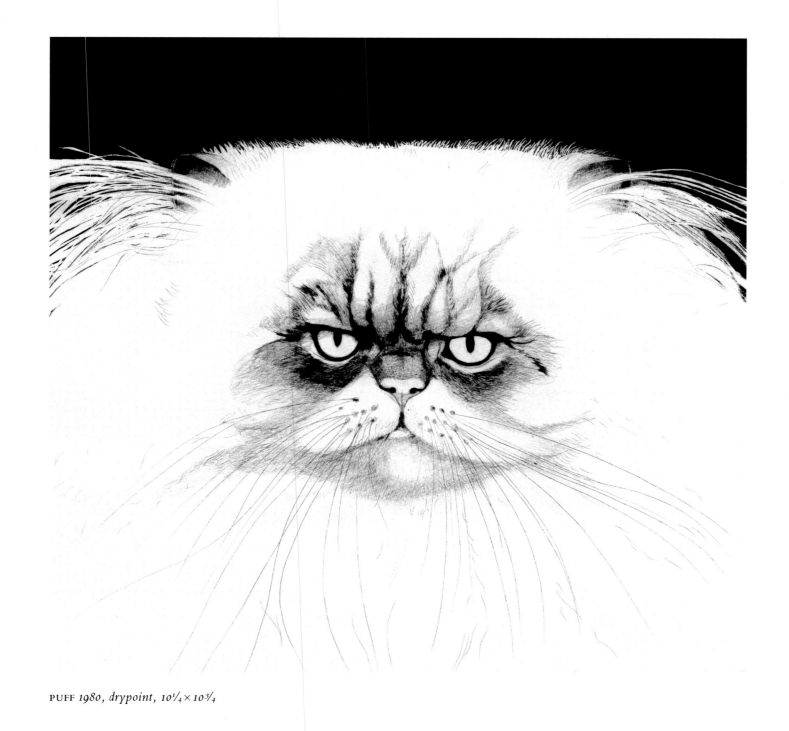

PUFF *1980, drypoint, 10¼ × 10¾*

NICKY *1986, aquatint, 5³⁄₈ × 5¹⁄₂*

DIVINITY *1986, watercolor,* 13¼ × 16¾

FLAMINGO DRINKING *1987, linocut, 5×4*

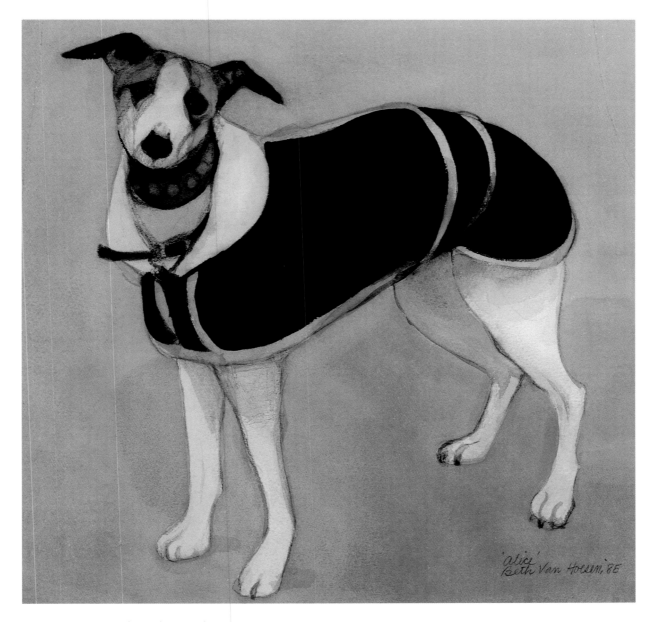

ALICE *1985, watercolor, color pencil, 12 × 12*

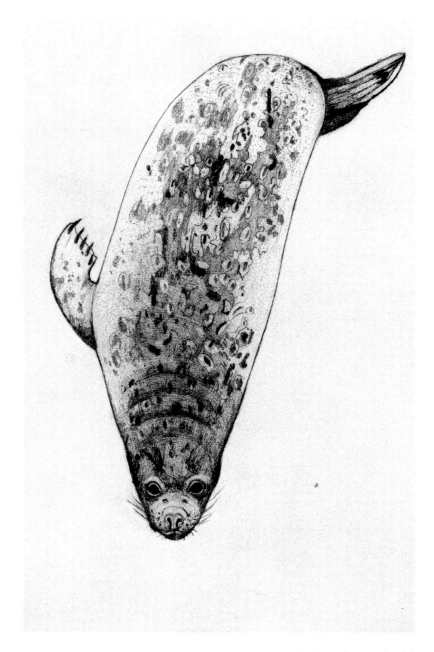

SPOTTED HARBOR SEAL *1985, drypoint, 10½×6½*

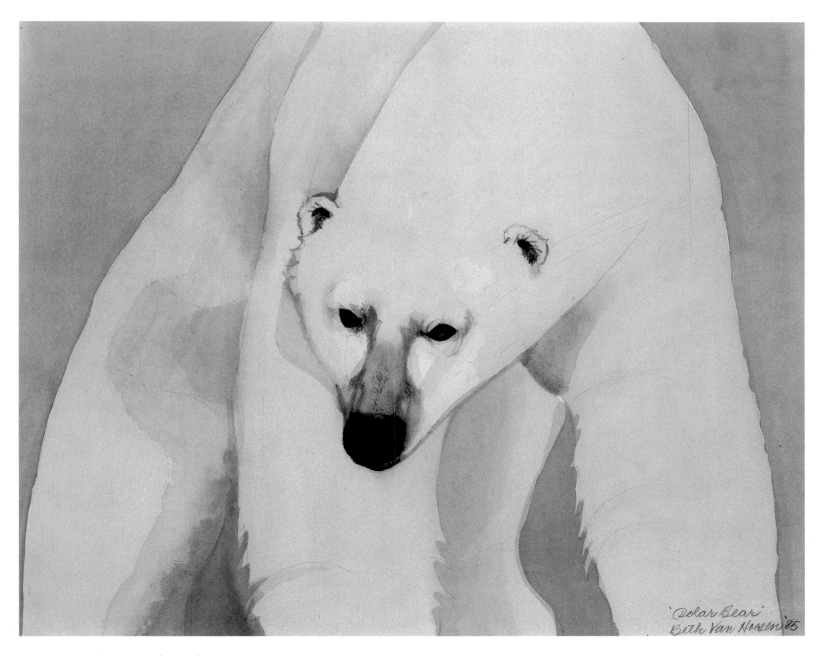

POLAR BEAR *1985, watercolor, 13¾ × 17*

Peaches

One day, on our way to St. Helena in northern California's wine country, we stopped at a store that sells exotic birds. A gorgeous pink-and-orange cockatoo named Peaches was perched on top of a square cage near the cash register.

I got out my colored pencils and pad and began to draw her portrait. She sat quietly for some time. Once she noticed me, however, she began to move, slowly backing away along the top edge of the cage. I hadn't finished my drawing, so I followed her. In this fashion we slowly circled the cage many times, completely unaware that an audience had formed to watch our curious ritual.

When I had finished and was leaving, Peaches resumed her original pose on the rim of the cage.

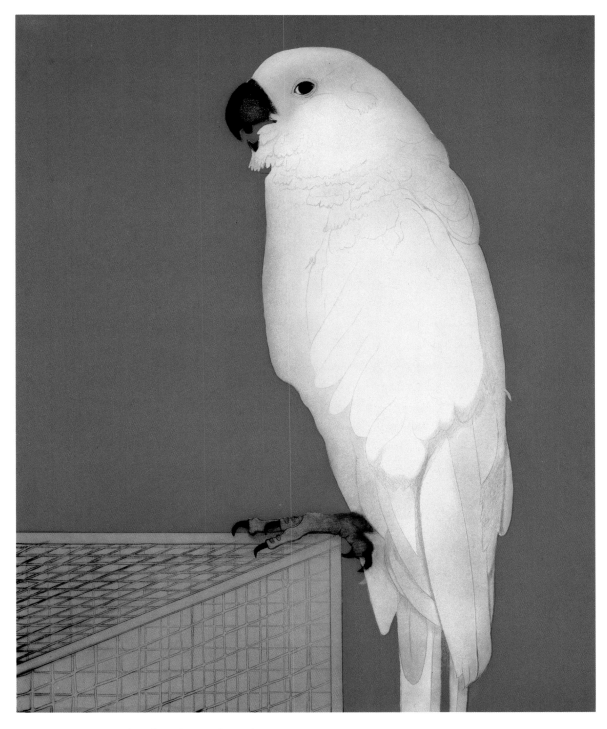

PEACHES *1981, aquatint, drypoint, 15¾ × 12½*

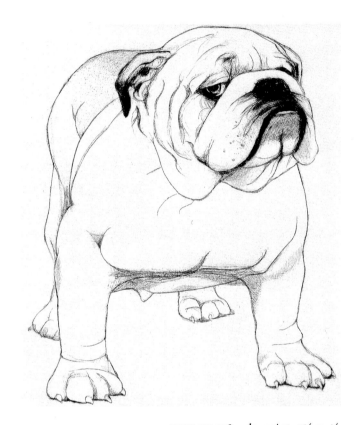

BOSLEY *1984, drypoint,* 5½ × 4½

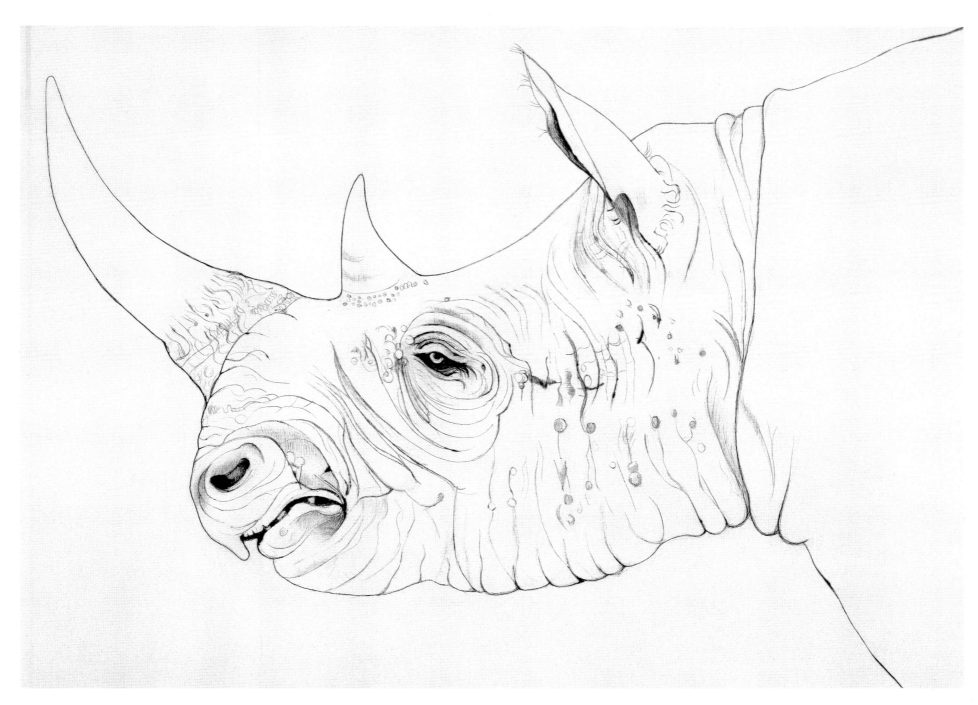

RHINO *1985, drypoint, 14×19*

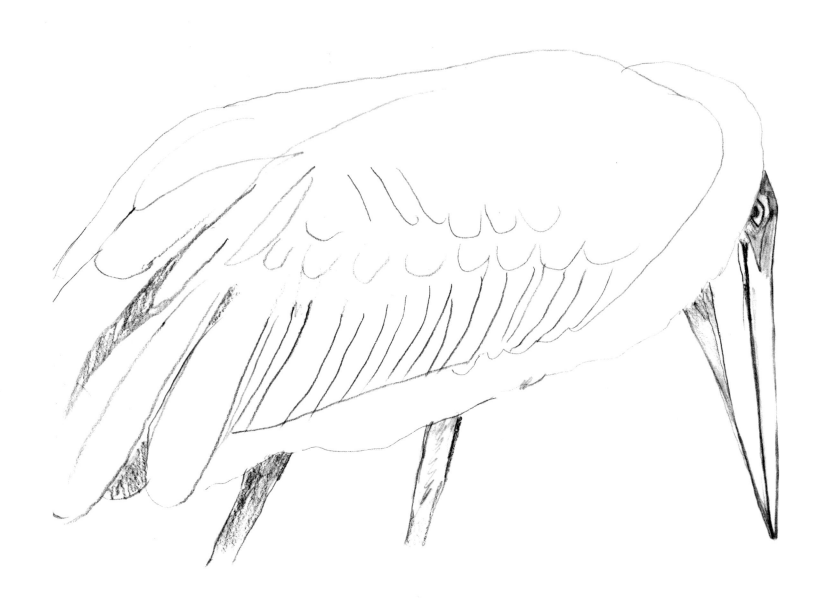

STORK DRAWING *1986, graphite, 14×17*

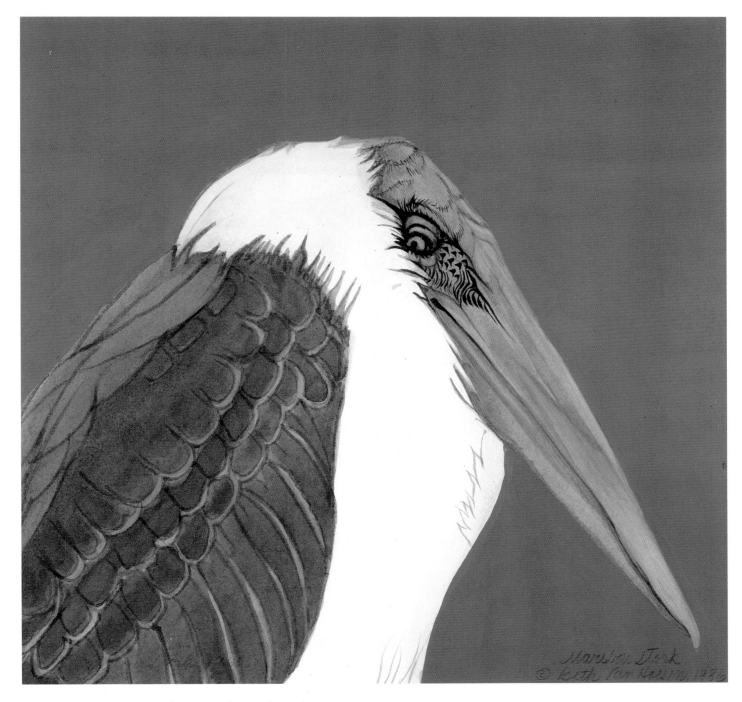

MARIBOU STORK *1986, acrylic, watercolor, 11³/₄ × 12¹/₄*

Marvin C.

My husband, Mark, gave me Marvin C. for Valentine's Day one year. I named him after a friend with dark eyes and round ears who was a printmaker. The "C" stands for chinchilla.

Marvin C. is from the mountains of Bolivia and bathes by rolling around in fine volcanic dust. He thinks you can't see him when he stands very still, so he was a very good model.

When he was two years old, we brought home a mate from the pet store. We called her Merla. Marvin and Merla snuggled together, and as time passed, Merla got fat and Marvin looked old and thin. Fat Merla died in her sleep one day, and Marvin began to gain weight. Merla had been eating his food.

We were told that the average life span for a chinchilla is four to five years. At the age of fifteen, Marvin still races up and down the hall for exercise. He can hide in surprisingly small places because his body, inside all that soft fur, is tiny. He continues to bring us delight.

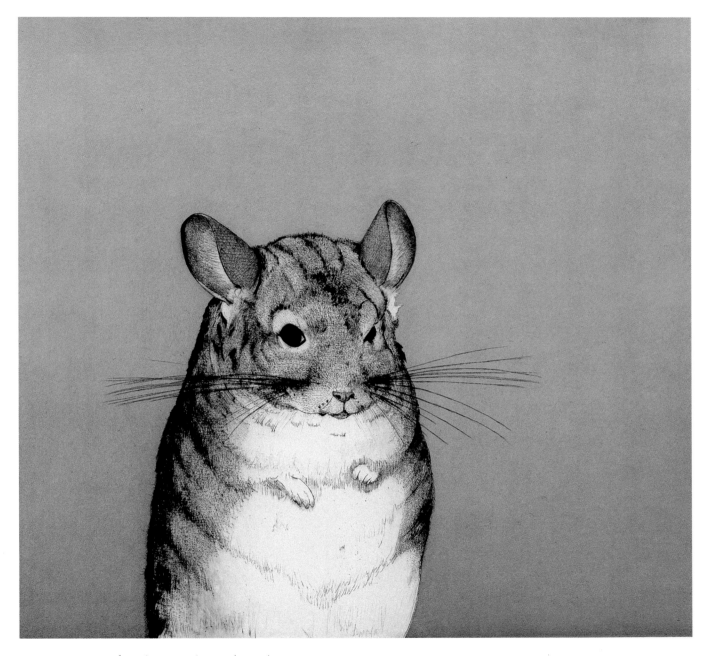

MARVIN C. *1979, drypoint, aquatint, 10¼ × 10¾*

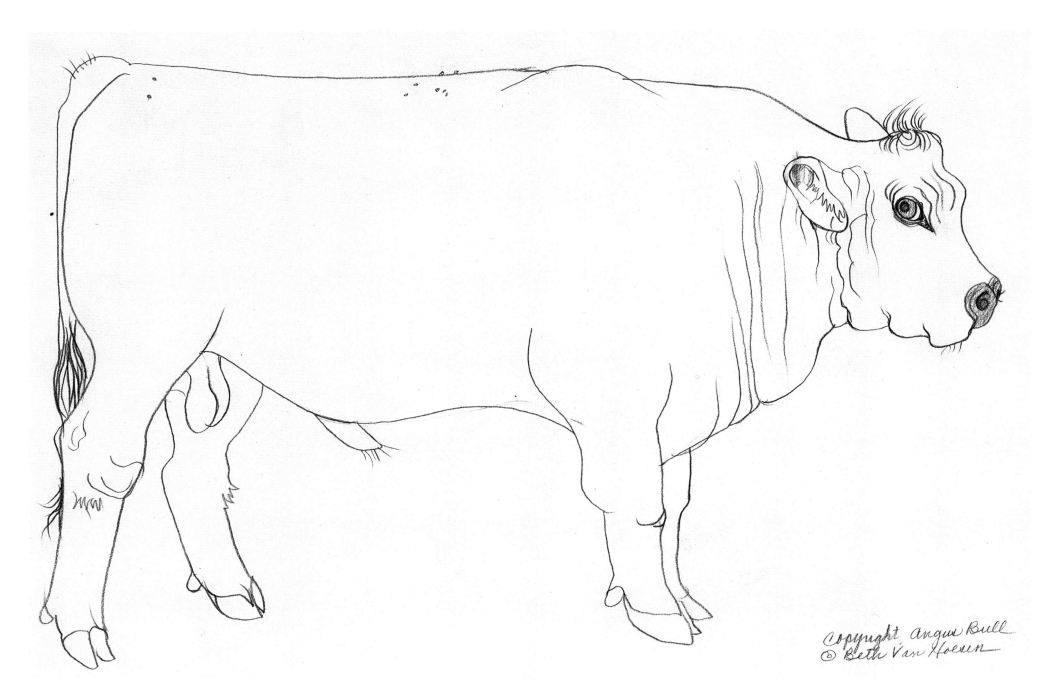

COPYRIGHT (THE ANGUS BULL) 1982, graphite, 12¾ × 18¾

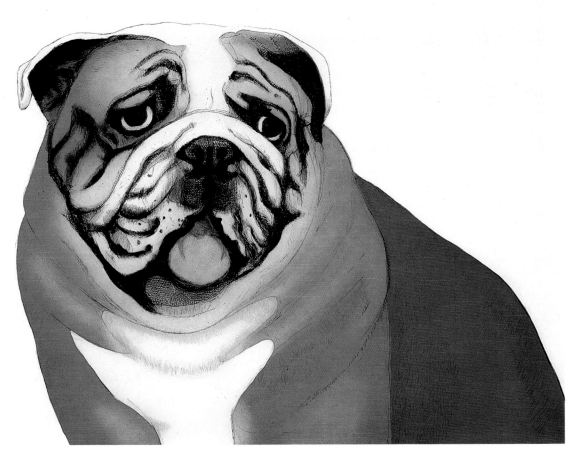

TOPPY *1985, etching, aquatint, watercolor, 12³/₄ × 15¹/₄*

Toulouse

Toulouse is a turkey vulture who lives at the Animal Research Center at the San Francisco zoo. I was intrigued with the contrast between his ugly little plucked red head and crew cut and his magnificent black wings with their tremendous spread. His feathers seemed iridescent. Toulouse was very much aware of me and would watch me continuously. If it was a hot day, he would spread his great wings and stand so the cooling breezes could reach his body.

I started out by drawing him from the front, but he would turn his back often and look at me over his shoulder. Finally I chose that pose.

After several days of drawing him, he didn't seem ugly at all.

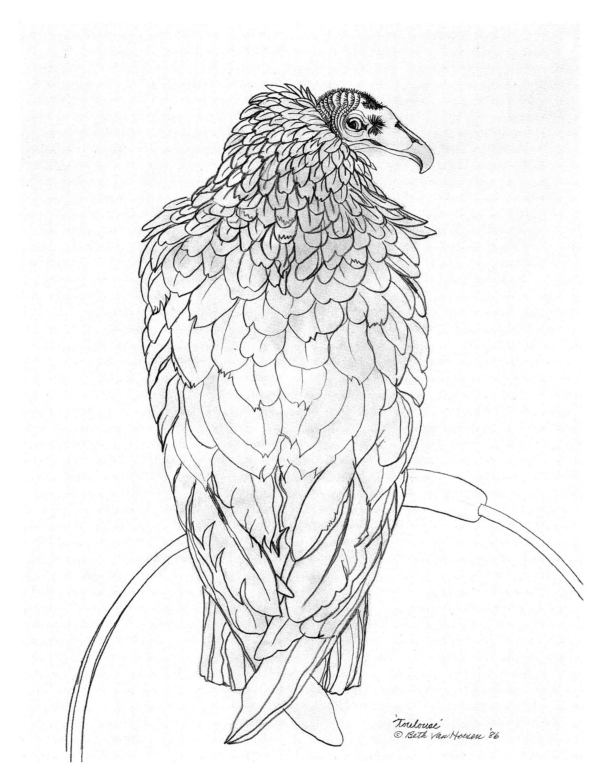

TOULOUSE *1986, graphite,* 25³/₄×19

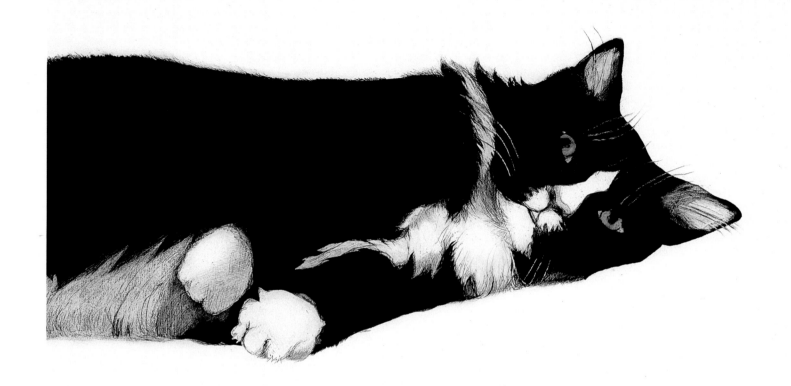

BOOTS *1985, drypoint, watercolor, 14×17*

BOSTON BULL *1985, softground etching,* 9¾ × 6¾

Lily of Noe

Lily of Noe belongs to two artist friends who live in the Noe Valley area of San Francisco. She is a long-haired calico cat of uncertain lineage. She came to our house in her carrying case to pose for me. When she arrived, she explored every part of the room, climbing over couches, crawling around vases, jumping on high desks, walking into partially open cabinets, and finally resting on a large painted chest.

While I watched her explore, there were many times I wanted to say, "Hold it," so I could capture her different poses. She sat, her tail slowly moving, looking haughty, spoiled, and bored. Did she know how beautiful she was? She didn't recognize my existence.

When her owners saw the first sketches, they said, "There is a little something wrong about the nose." People often say that when they see a portrait of a relative.

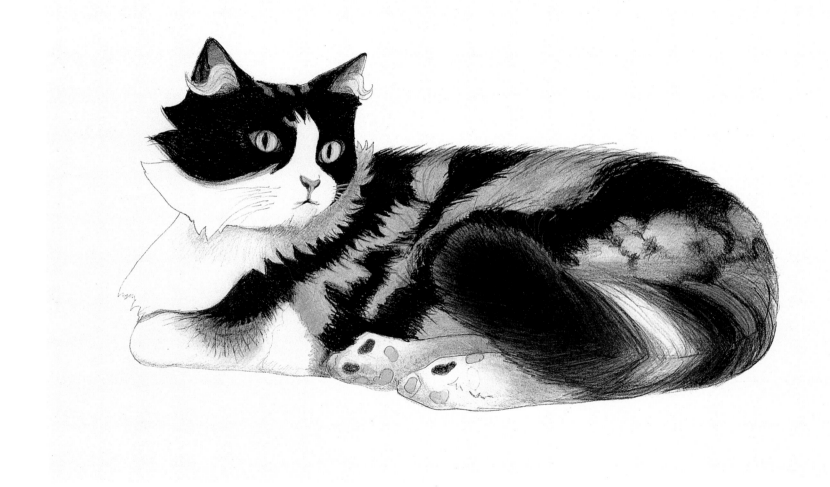

LILY OF NOE *1985, lithograph, 13¼×16*

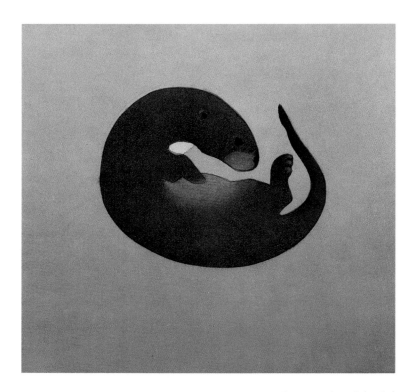

OTTER FROM MONTEREY *1987, aquatint, 6½ × 6¾*

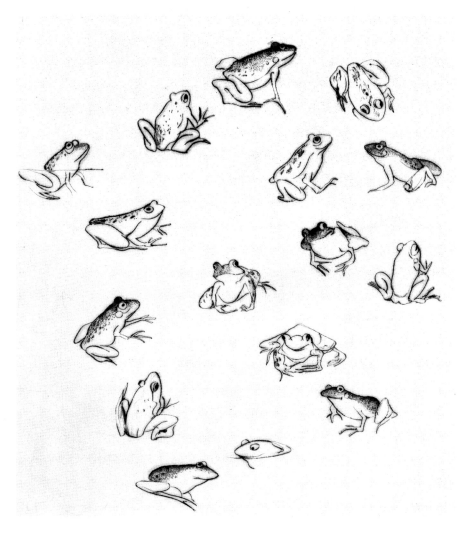

LEONARD LAKE FROGS *1978, drypoint, 7½×6*

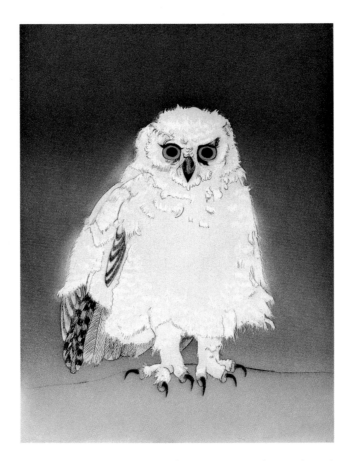

OWLET *1982, aquatint, drypoint, watercolor,* $10\frac{3}{4} \times 7\frac{3}{4}$

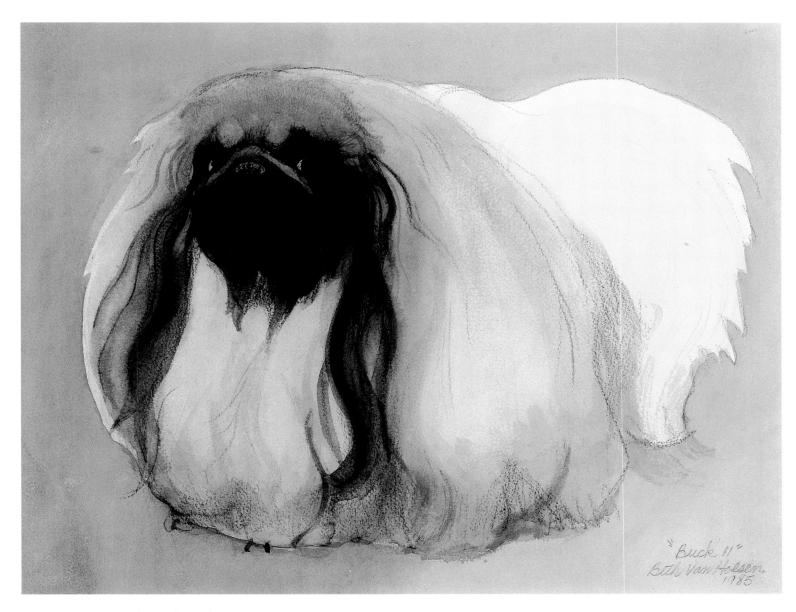

BUCK II *1985, watercolor, 11½ × 14¾*

Bugs

Bugs is a cat that belongs to my printer, Tim, and his artist wife, Barbara. He came for two sittings, and I drew him in his favorite position on our Oriental rug. When I asked Barbara about him, she sent this biography.

"Bugs was born in Cleveland, Ohio. His mother was a striped tabby, as were the other three kittens in the litter (all female). Bugs was born last and was bigger than the other kittens. He was all white at birth and didn't breathe. His mother ignored him, and it appeared as though he wasn't going to make it. I had to massage him to make him breathe, and after a day or so, when his mother finally accepted him, he was the strangest, biggest, and loudest of the litter. I named him Bugs after Bugs Bunny because he looked like a rabbit when he was born. He was very ugly. After two or three weeks, his tail and ears and nose were sable; then gradually he took on the markings of a Himalayan, with long fur. He has always been peculiar and seems to meditate a lot. I call him The Mahatma because of his nonviolent response to aggression in other animals. He has never been in a fight and has stared down the meanest of adversaries, from German shepherds to tomcats. They just back off.

"Most of the time, Bugs sleeps upside down with his feet up in the air—like in the print. He lumbers around slowly, doesn't care about birds or other cat things—he actually dragged in a dead bird once, stiff and old, as if he were trying to be a cat but didn't quite know how. He is a strange cat, who seems to combine a deep wisdom of some sort with a profound dumbness. He is a never-ending source of affection and amusement."

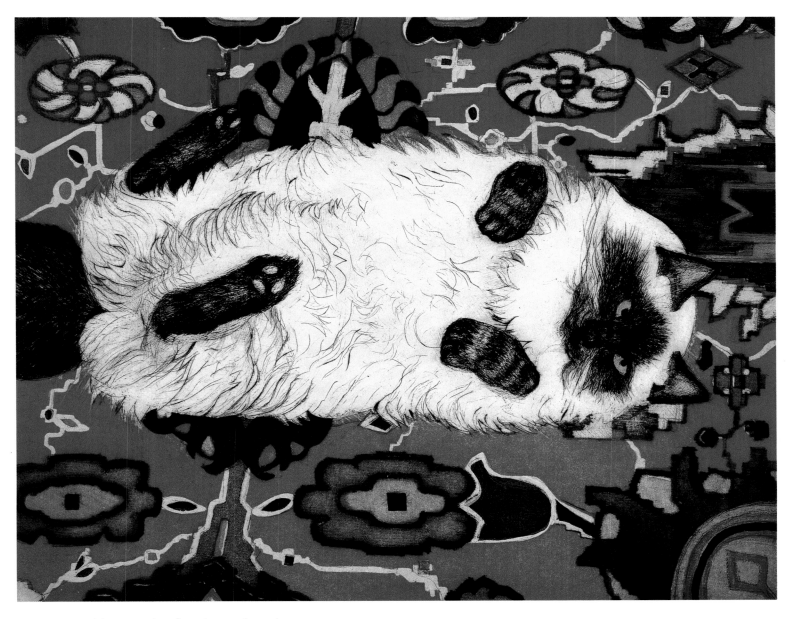

BUGS *1985, etching, aquatint, drypoint, 10¾ × 13¼*

Miss Megan

In India once I squeezed past a Brahman cow on a narrow street, and I have wanted to draw one ever since. A collector who owns several of my animal prints sent photographs of her beautiful new white Brahman cows. I called her and made an appointment to draw them. It was a beautiful farm with a pond among rolling pastures—an ideal place for cows to live. There were six females and one brown bull named Rhett. They didn't scare me the way some other breeds do, perhaps because of their doelike eyes with long lashes and sympathetic expressions. Hay was unloaded from the truck, and after eating, they all came very close to investigate. They came so close at times that their noses were nearly on the drawing pad! Usually they are around people only when they are fed; even so, they all stayed with us and seemed curious about us and our station wagon. They did not leave until I had finished two hours later.

I drew two of the cows—Miss Megan and Miss Greta. They are called "Miss" because they have not yet been bred.

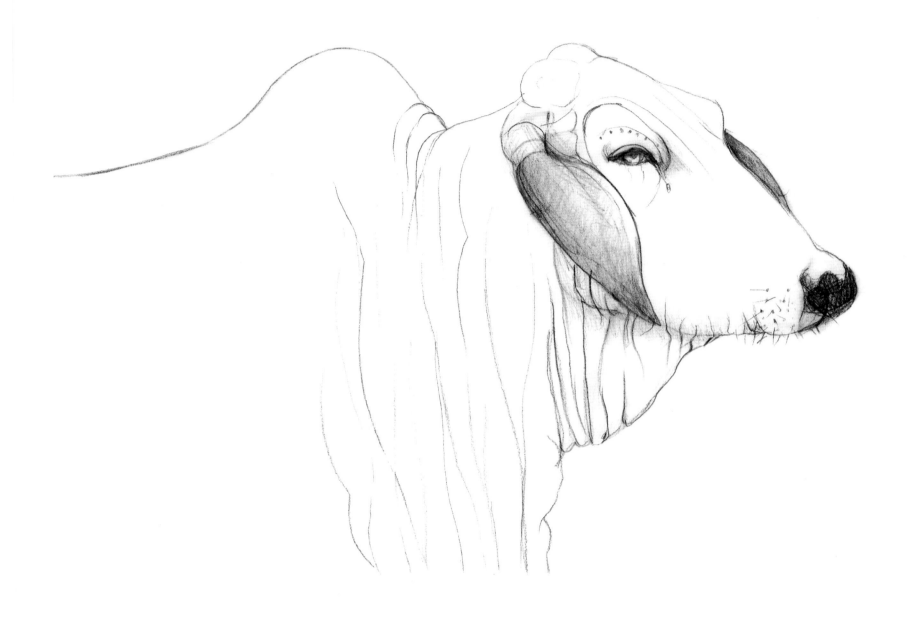

MISS MEGAN *1986, graphite, 12 × 14¹/₂*

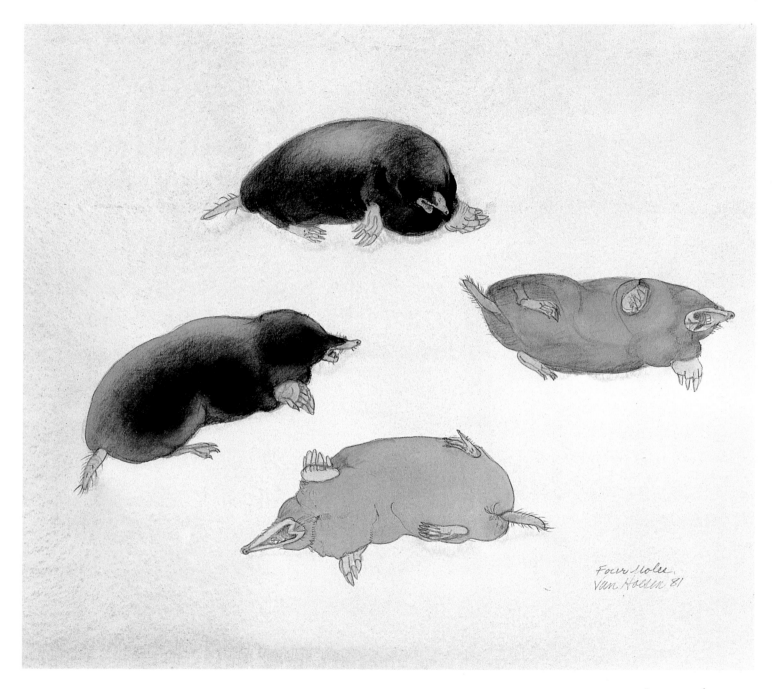

FOUR MOLES *1981, watercolor, 13×14*

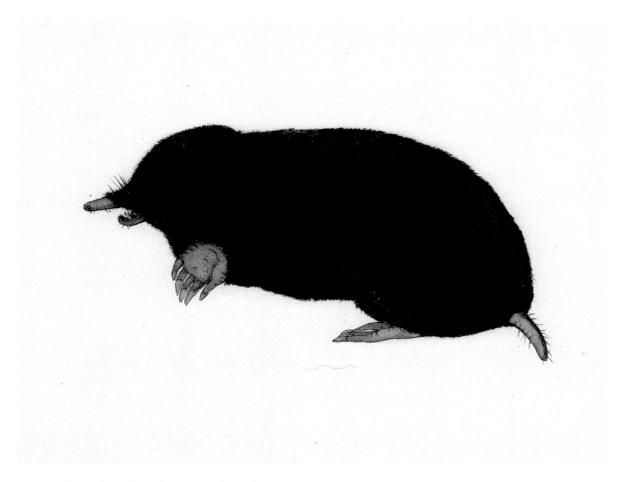

MOLE *1982, roulette, drypoint, watercolor, 5½ × 7¼*

Sedona

The tigers at the San Francisco zoo lie around on the grass and rocks beyond their moat. I could not get close enough to do a portrait. I decided to go to the Lion Hall for the two o'clock feeding. There I sat very close to the cage of a tiger named Sedona, who was part Bengal and part Siberian. Each tiger's stripes are different, and I wanted to capture Sedona's individuality. She was pacing—waiting for her lunch—while I watched. Soon they brought her a big bone, and she settled down gnawing, looking up occasionally while I was drawing. When several lions were let in to be fed in cages at the far end of the room, a group of lions near Sedona began to roar at them. The lions roared back and forth, and the huge hall echoed with waves of booming roars. Sedona was scared. Her ears were back and her eyes were wide.

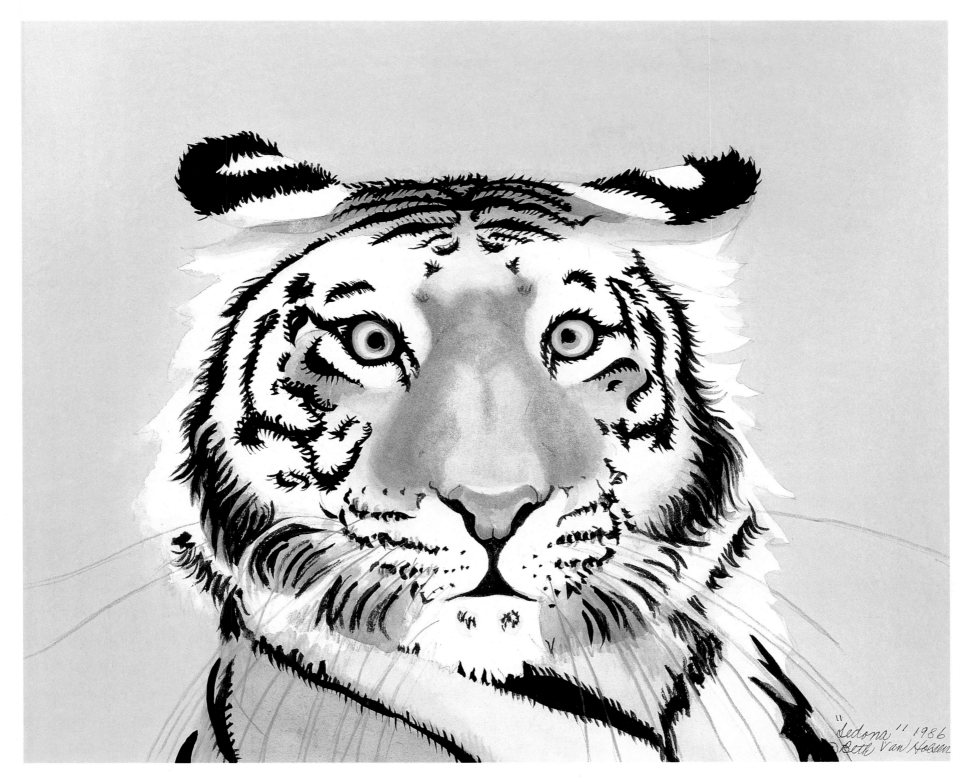

SEDONA *1986, watercolor, 14 × 16¾*

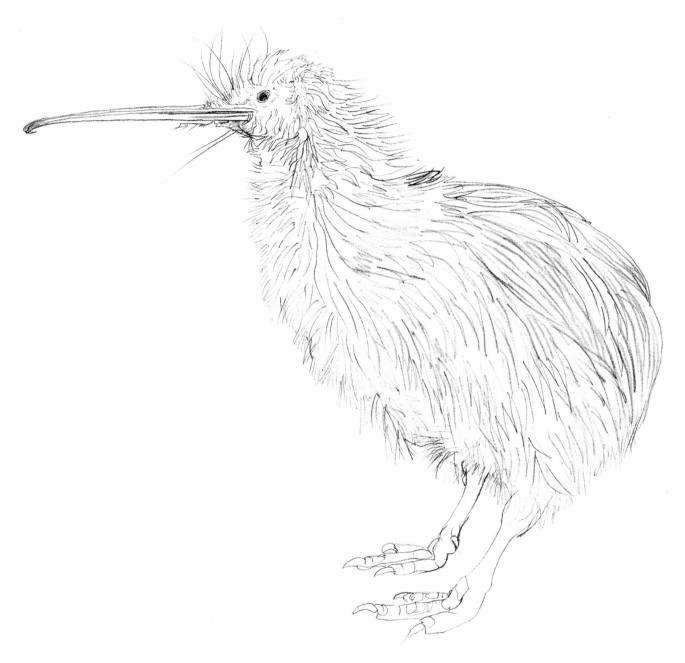

KIWI *1981, graphite, 14×17*

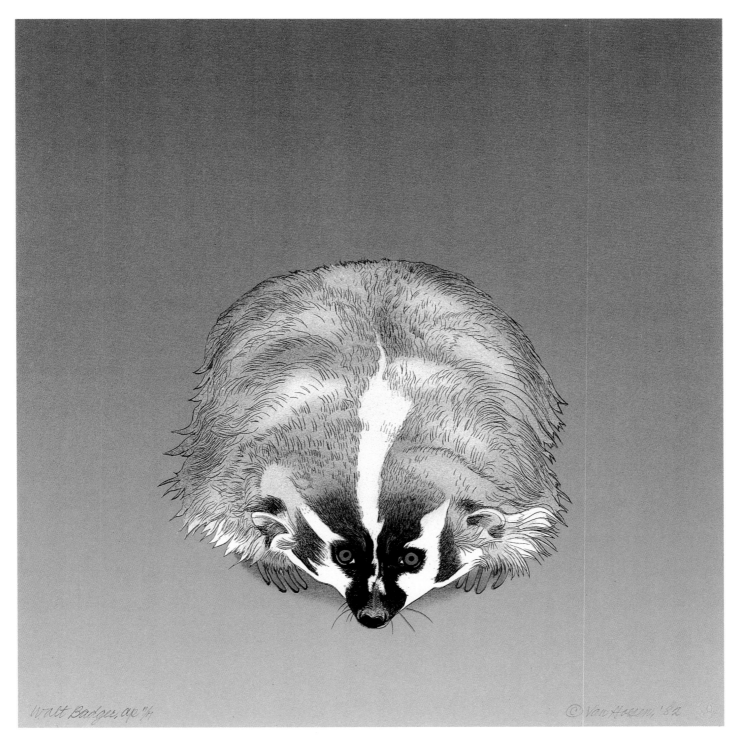

WALT BADGER *1982, lithograph, 15½ × 15*

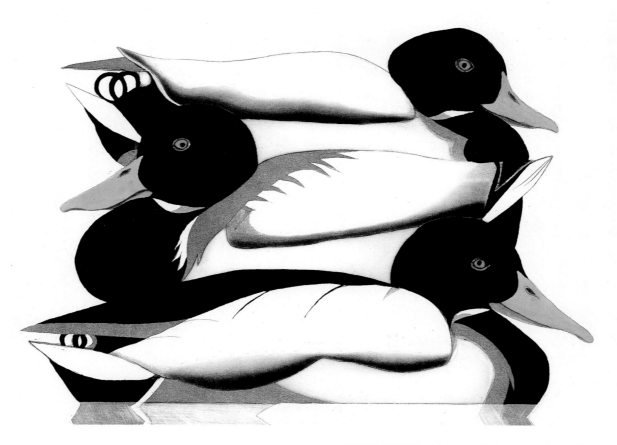

THREE DUCKS *1987, aquatint, watercolor, 8³⁄₈ × 11⁷⁄₈*

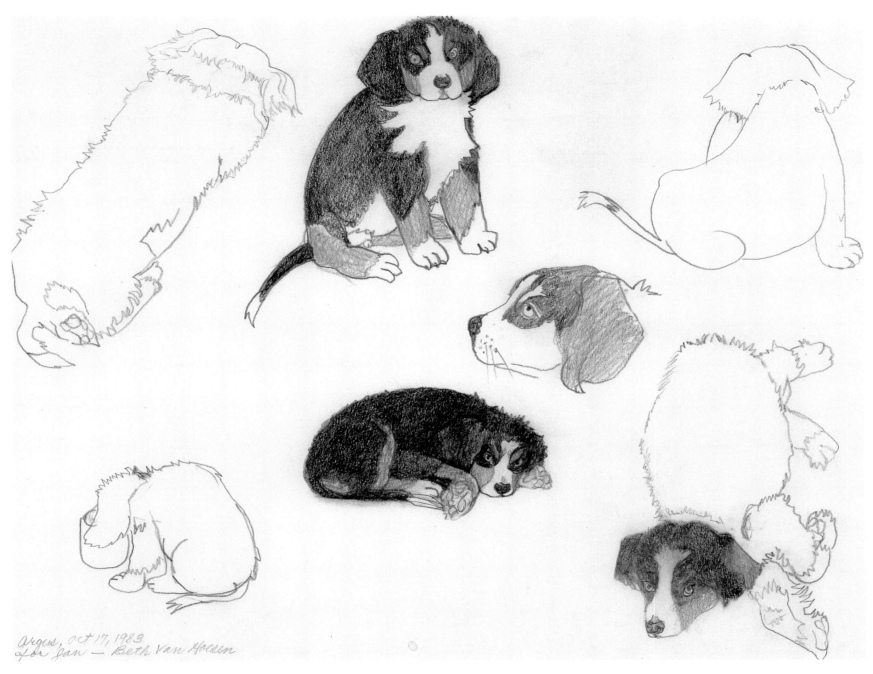

Argus, Oct 17, 1983
for Jan — Beth Van Hoesen

ARGUS STUDIES *1983, graphite, color pencil, 12½ × 17*

Argus

When our friend Jan's old dog died, we had no doubt that she would soon want a new puppy. Jan and her husband had never owned purebred dogs, but now they started reading books, going to dog shows, and investigating the personalities of various breeds. They couldn't find just the right kind.

While visiting Boston, Jan saw her dream dog walking down the street. She chased the dog and its owner and discovered that it was a Bernese mountain dog. When Jan and her husband returned to California, they contacted a breeder who interviewed Jan and her husband before agreeing to sell them a dog. They passed the test, and a few months later Argus arrived from Michigan.

When we met Argus, he was all a puppy should be—big feet, floppy ears, and an armful of friendly licks. People stopped on the street to exclaim over him.

I don't usually try to portray such cuteness, but I couldn't resist Argus. The first time I drew him, we had a morning of laughter and exasperation. The results were pages of paws and ears. The second time, Argus waited by the door for Jan, and I was able to draw him.

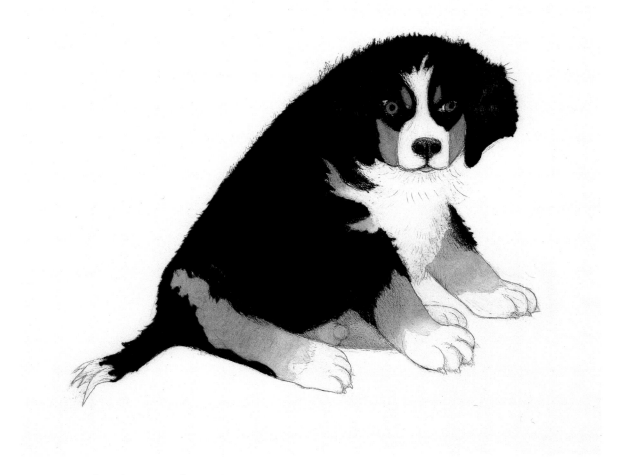

ARGUS *1985, drypoint, watercolor, 7 × 8*

Giant Cow

I have always been curious about the sideshow tents at fairs that advertise miniature horses, five-legged sheep, three-foot-long rats, and so on. When I was drawing bulls at the Grand National Livestock Exposition, there was a big tent with a sign: SEE THE GIANT COW—50 CENTS. Mark said that it was probably dead and stuffed, but I wanted to see it anyway. We went in. There was this absolutely huge cow, very much alive and perfectly proportioned. It nearly filled the whole tent! There was a little walkway around the cow. You couldn't see all of the cow at once. I would have liked to have seen a normal-size cow next to the giant cow to get the scale.

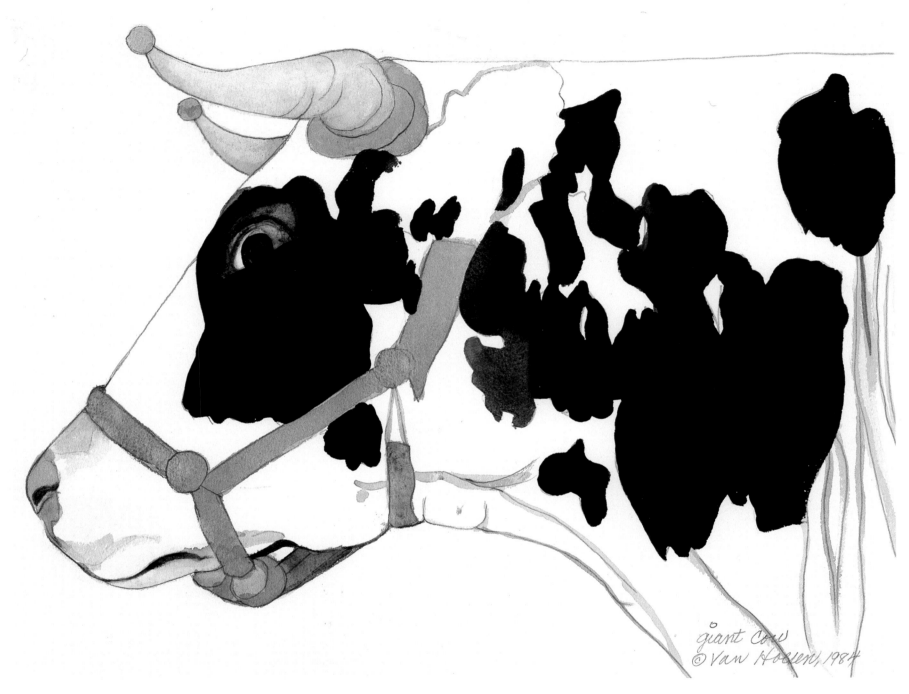

GIANT COW *1984, watercolor, 12×15¼*

Rani

I have always been enamored by the smooth fur and wonderful shape of mountain lions, which are also called cougars or pumas. I tried to draw them in zoos, but they were always pacing back and forth behind double-barred cages, so I couldn't see them clearly. I called the animal park near San Francisco and made an appointment with Jeff, the trainer of a six-year-old mountain lion named Maharani—Rani for short.

When I first saw her, she was being led down the walk among the visitors with only a chain to restrain her. The destination was a grassy knoll, where she lay down and snuggled up to Jeff, licking his face. Rani had been raised in captivity with a leopard and was used to being handled by trainers. She had that graceful languid appearance of most cats. But her powerful body reminded one that her effortless relaxation could turn to aggression in an instant.

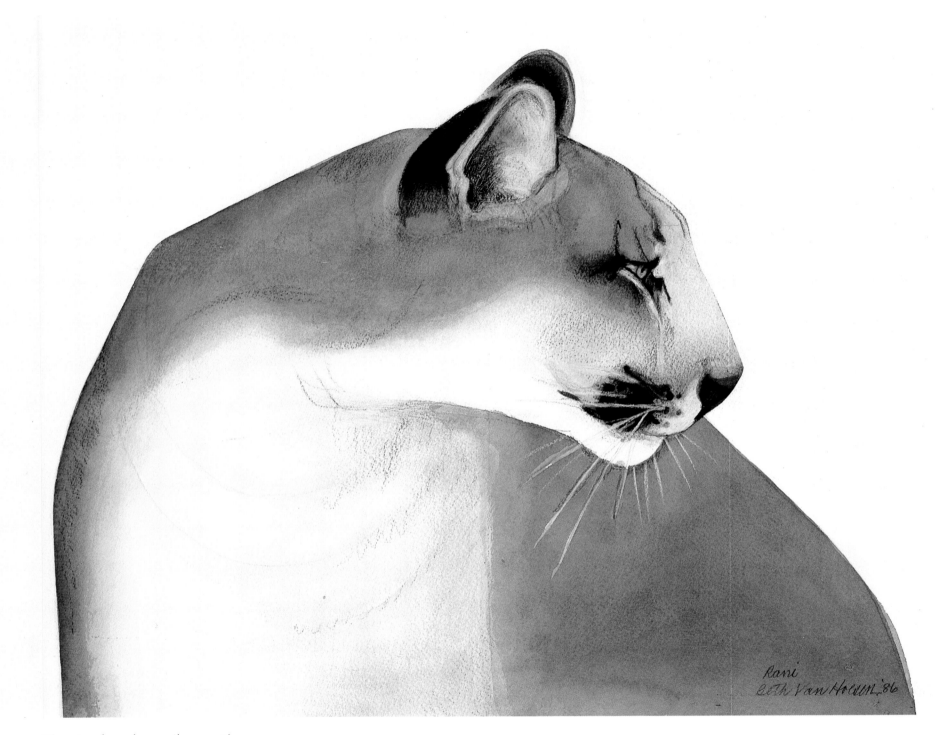

RANI *1986, watercolor, color pencil, 14 × 19½*

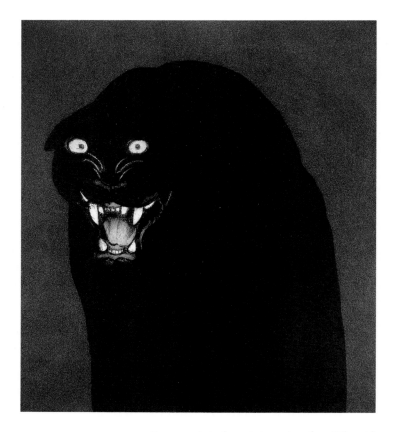

PANTHER *1987, aquatint, drypoint, watercolor, 6½×5⅝*

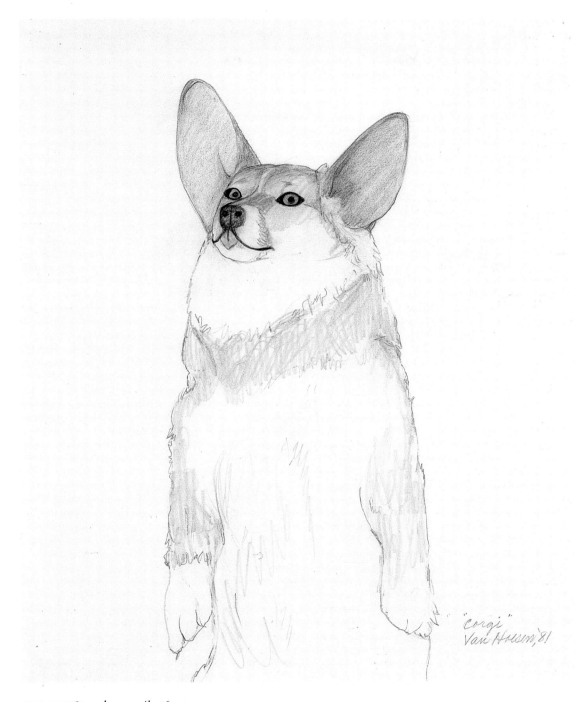

CORGI *1981, color pencil, 16×13*

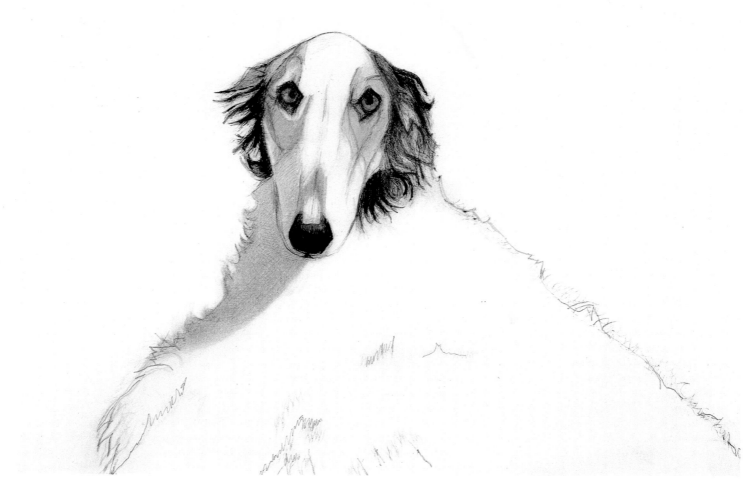

DAZZLE *1985, drypoint, watercolor, 11⅛ × 11¾*

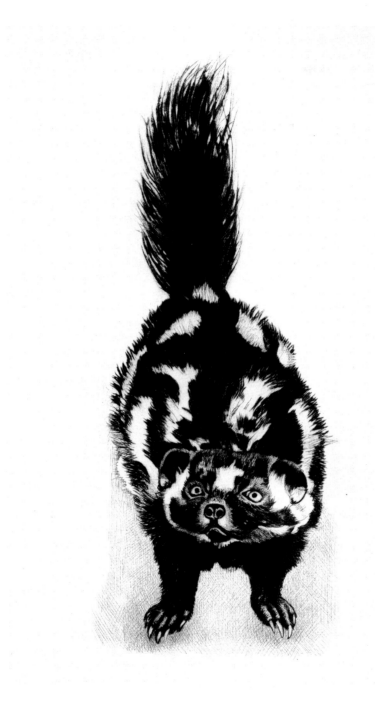

FLEUR *1983, drypoint, 11¼ × 6¾*

Alex and Claire

It is difficult to find barnyard animals when you live in the city. I read about The Farm, located under one of the San Francisco freeways, which had animals for city children to get to know. My husband and I went there for the purpose of borrowing an animal to draw. There were some spectacular China geese with bumps above their beaks. The director agreed to let us take a pair home. We loaded a big cage into the back of our station wagon; then Mark and the director had quite a time lifting the big geese into the cage. As we drove home, there was much fussing and honking. People on the street stopped to stare. We had to go up and down several hills to get to our house, and the geese would slide to the back and then to the front, honking all the time. At home, quite a crowd of neighbors gathered while we unloaded the geese and put them in the garden at the back of the house with a big pan of water and food. They finally settled down.

I drew them each day, and they soon became used to my presence. After they had eaten, they would take naps—sometimes putting their heads under their wings and sometimes standing on one foot. One was a male and the other a female, and their personalities were quite different. Their little teeth and the color of their eyes fascinated me. They stayed with us for a week, and they honked early in the morning as well as when they were hungry or when people came near. They were much louder than barking dogs, and I am surprised that the neighbors didn't call to complain. It was so quiet after they went back to The Farm.

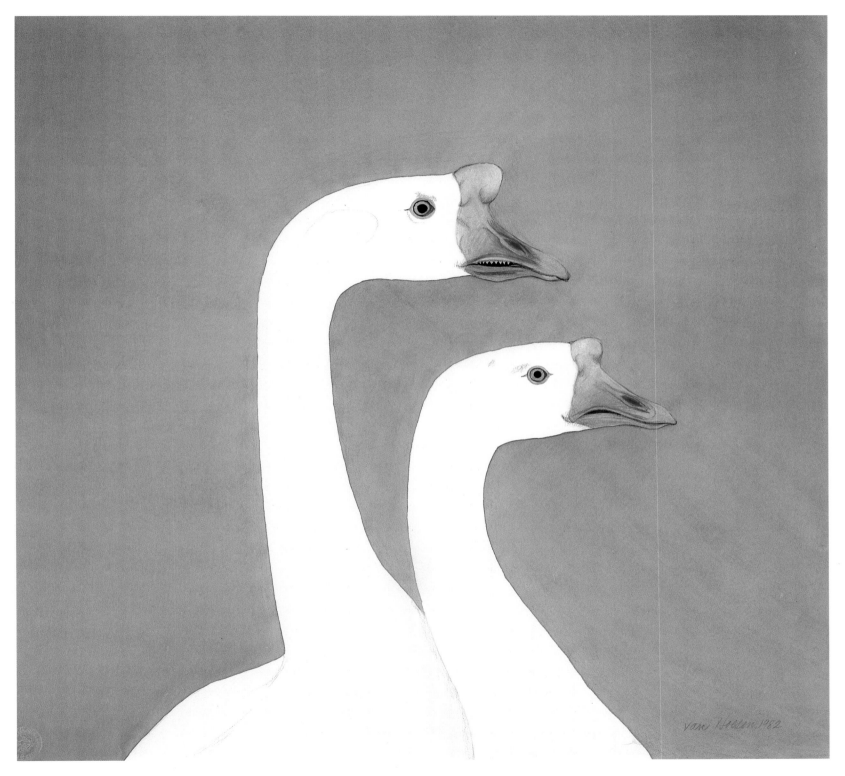

ALEX AND CLAIRE *1982, watercolor, color pencil, 19 × 20*

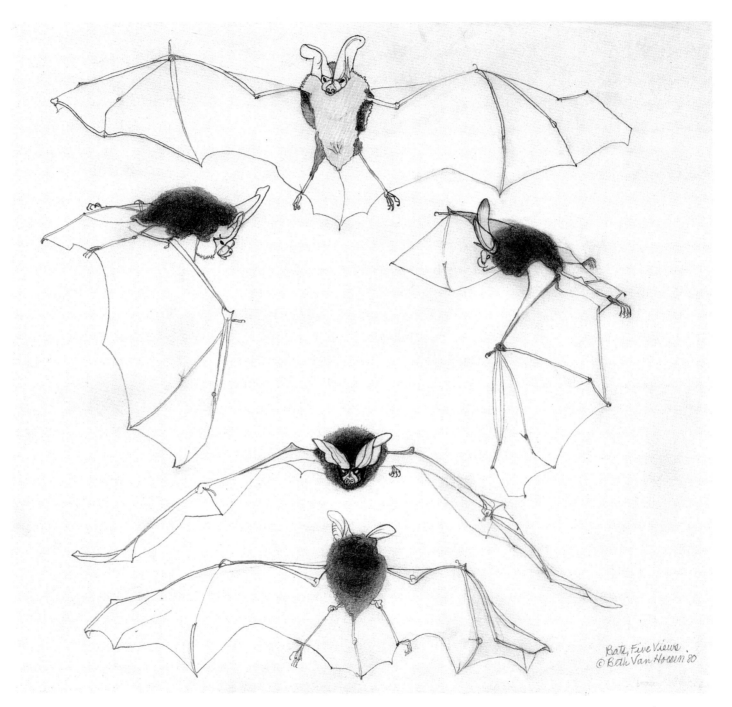

BATS, FIVE VIEWS *1980, graphite, 14 × 14*

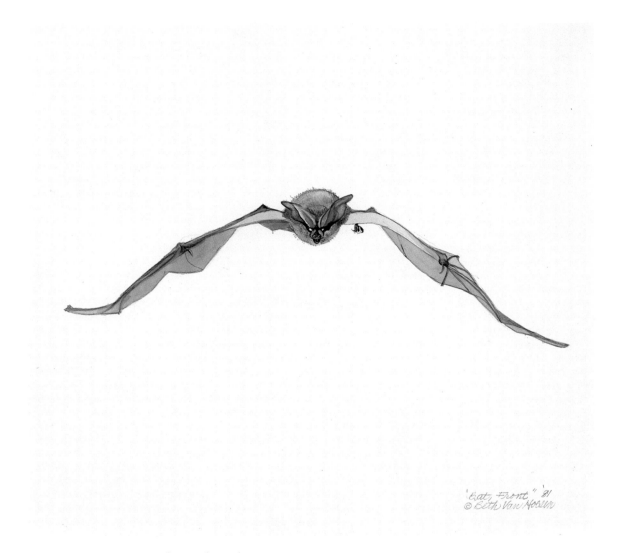

BAT, FRONT *1981, watercolor, 10¾ × 12½*

Francis Duckling

One spring some friends who live on the spit at the seashore near San Francisco gave us a newly hatched mallard duckling named Francis Drake, after the explorer who had landed at a nearby beach.

Francis was pale yellow fluff with big feet when I made a drypoint plate of him, but he soon outgrew his first cage. Two cages and a change of feathers later, it became clear that Francis was not a drake but a duck, and she was accordingly renamed Frances Duck.

I drew Frances again when she was a teenager. She would eat the tender new fronds from the ferns and beg from our luncheon tray by pulling on a corner of the napkin. She started quacking as soon as the sun came up.

One day she was flapping her wings dry after her bath and suddenly took off into the air, startling herself as much as she did us. It was time to let Frances go.

I called Golden Gate Park and asked if there was a small lake where there were mallards that would be a nice place for a picnic. The woman who answered the phone asked if I had a duck I wanted to set free.

We took Frances to a lake in the park, which seemed like a lovely spot for her. She waddled happily into the water, but rushed back to us when other mallards approached her. She returned home with us that day.

Eventually we found a nice pond at a restaurant where the ducks were well fed. When we left Frances after lunch, she was already busy with her new friends.

Sometimes in the early morning I think I can hear Frances quacking.

FRANCIS DUCKLING *1971, drypoint, watercolor, 4¾×7*

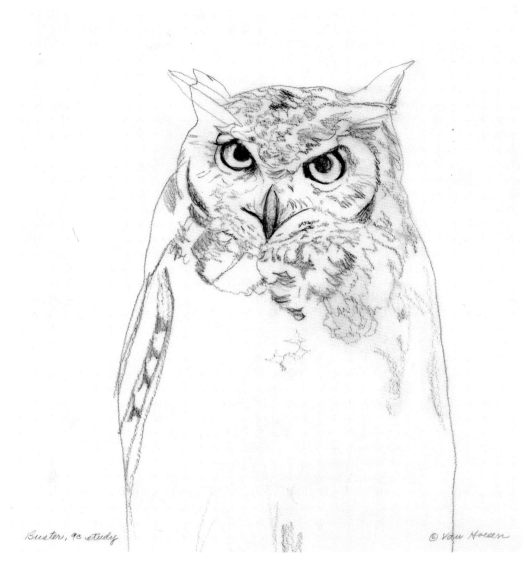

Buster, 9c study

© Van Hosen

BUSTER #9C, STUDY *1982, graphite, 15½×14*

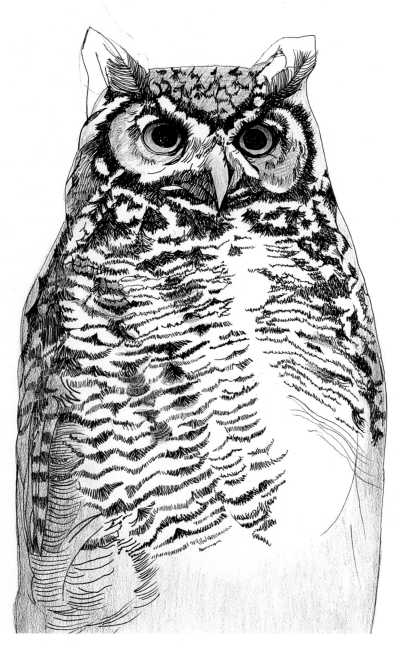

Buster, No. 5B study
1982
Beth Van Hoesen

BUSTER #5B, STUDY *1982, ink, 17×21*

73

Buster

Buster lives in an animal shelter. The young people who take care of the animals there named him. He had an injured wing and sat quite still, but as I drew him, he made many slow movements. His intense stare matched mine, although he didn't try to outstare me and often looked away.

I found it almost impossible to draw the individual feathers because the overall pattern disguised the shape. I searched my mounted animal resources and found a great horned owl in the back bins of the California Academy of Sciences, where I could explore the feather shapes in detail. Since all bird feather patterns are different, I still had to return to the animal shelter to draw Buster's individual patterns. I found him sitting in the same position.

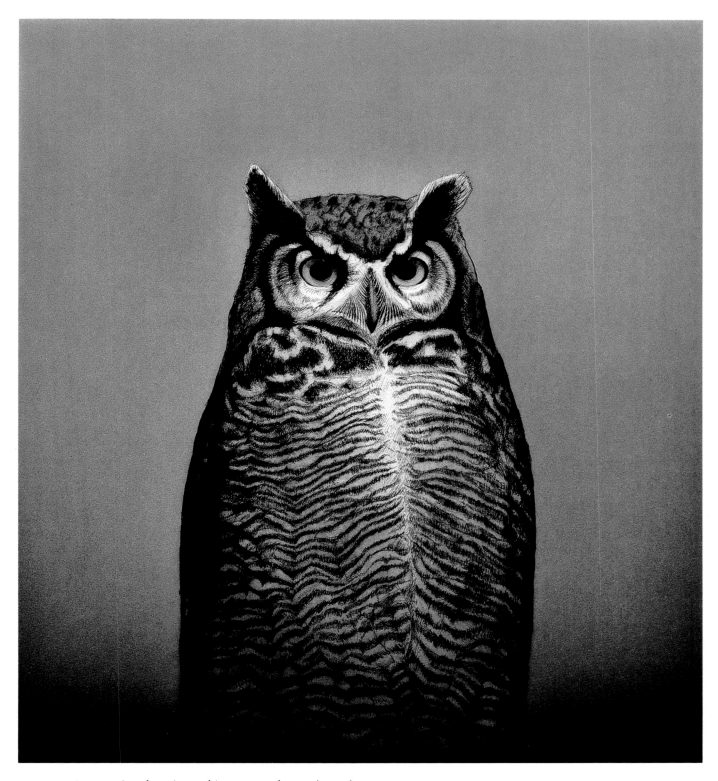

BUSTER *1982, aquatint, drypoint, etching, watercolor, 19¾ × 17¾*

Prize Bull

For several years I had been looking for the type of prize bull I had seen in large photo blowups at Cattleman restaurants. This breed had short legs and a huge rectangular body that almost touched the ground. We searched the county fairs, and I met a lot of big breeder bulls. At one of the fairs I found a large Hereford bull, a 4-H prizewinner. His teenage owner was pleased that I was interested in El Grand Domingo—called Jim for short. I was able to get very close to the stall and his huge eye, which looked at me while he munched hay. I admit to being unnerved by the immense size of these bulls, but Jim seemed quite gentle, following a tiny girl who led him out of the barn to be washed.

I never did find my rectangular bull—and later learned that that type was "out of style" since the present market prefers less fat.

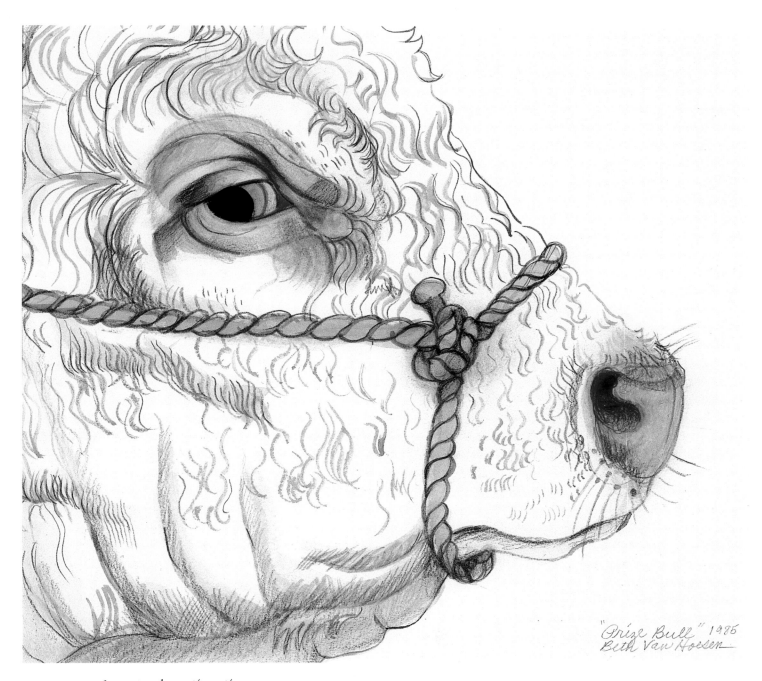

PRIZE BULL *1985, watercolor, 11½×12½*

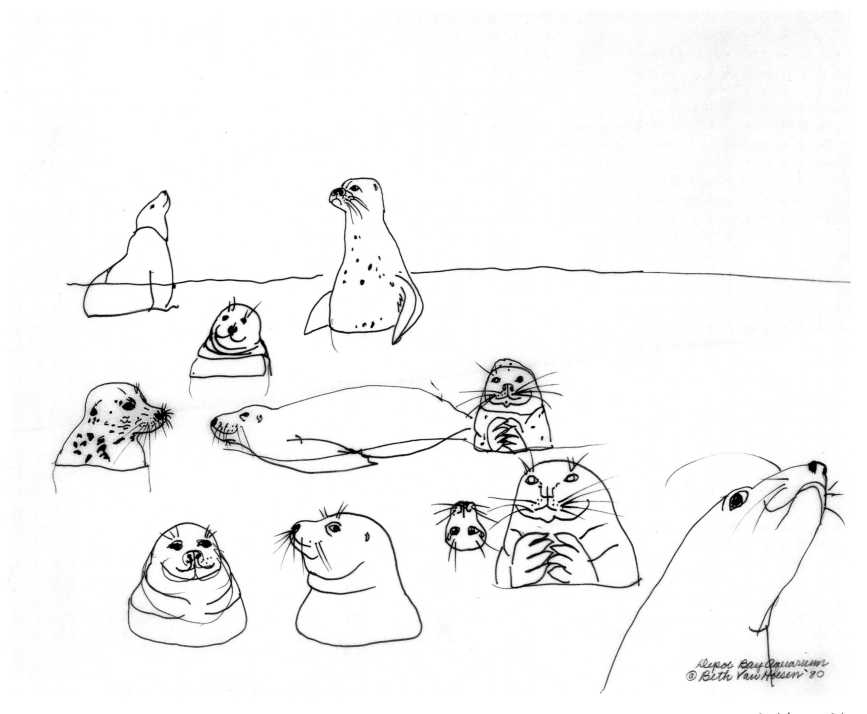

DEPOE BAY AQUARIUM *1980, ink, 14×16¼*

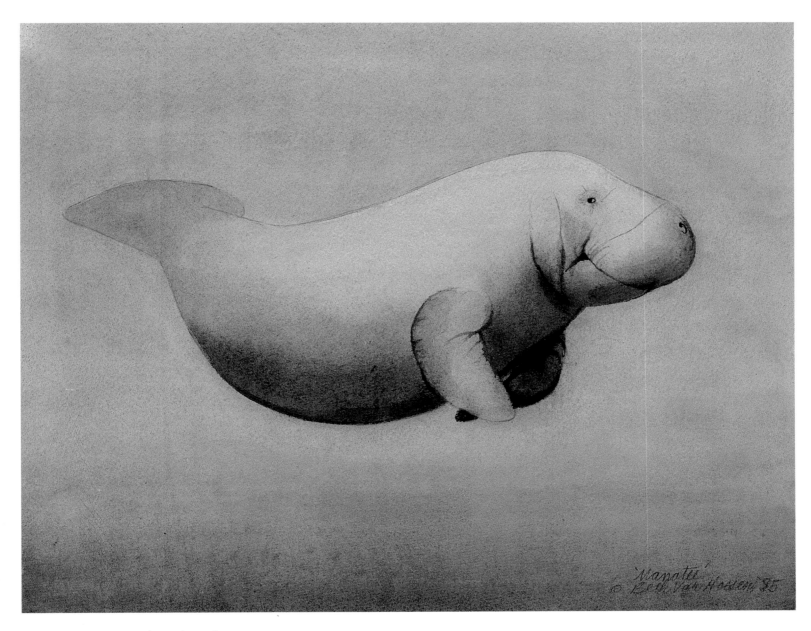

MANATEE *1985, watercolor, 9¾ × 12¼*

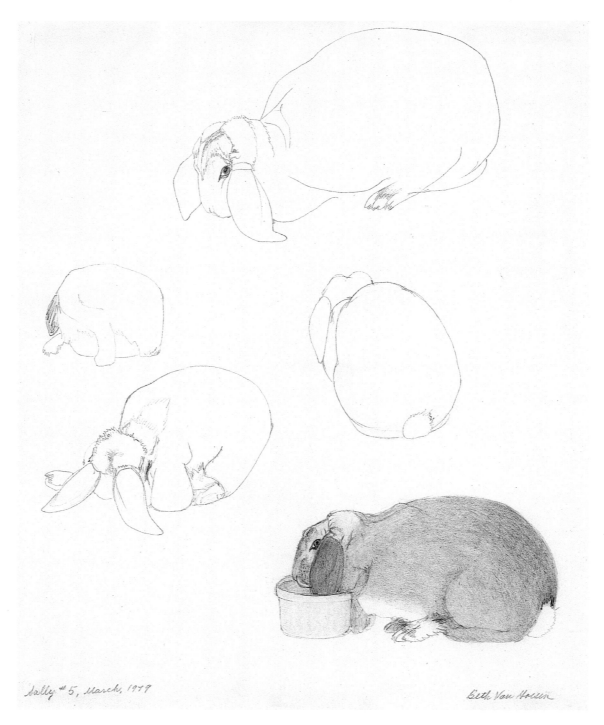

Beth Van Hoesen

SALLY #5, STUDY *1979, graphite, color pencil, 17 × 14*

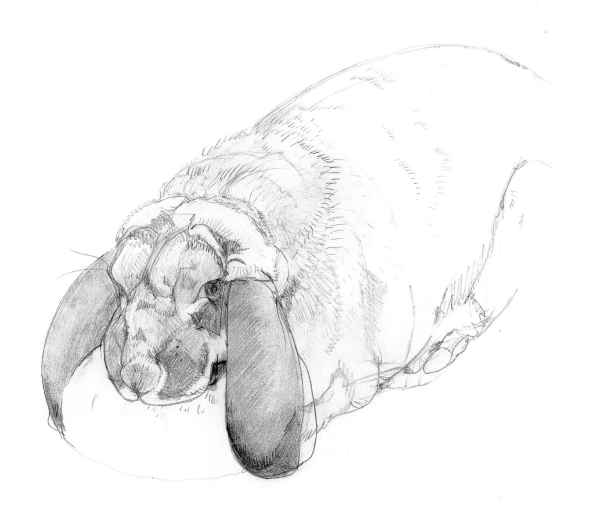

#13
March 7, 1979

B.U.H

SALLY #13, STUDY 1979, *graphite, color pencil, 17×14*

Sally

When my husband, Mark, was teaching at the University of California at Davis, he met two young veterinarians who were raising French lop rabbits. This variety is raised to show, not to eat. They're large, about the size of a cocker spaniel, and their ears droop down instead of standing up. Mark and I were both entranced with them, so we brought two young ones home.

The ears of the bunnies stand up, falling down only when they get older. It's very cute because one ear always falls down before the other. I got some cat leashes for our bunnies, and we'd take them for walks on the street. People thought they were puppies. They hop along at a fast pace and have a lot of strength . . . it's very hard to control where they go. They go where they want!

Sally was the mother of our bunnies. She came to stay with us while her owners were away on vacation. She lived in a very large cage in our backyard, and every morning I'd sit in the same place next to the cage to draw her.

Sally had her habits: first she'd eat, then she'd wash her face, and then she'd settle down to take a nap, always in the same place. This was the pose I wanted, but she would hold it for only a short time. When she fell asleep, her head would sink into the dewlap of fur around her neck, which would cover her face. Then I'd wake her up, and we'd go through the routine all over. It might take half an hour to get her in the right position again.

I drew Sally for ten days. As time went on, she became annoyed with me and would give me dirty looks. She wasn't a nice sweet rabbit; she was feisty. One day she decided she had had it and turned her back to me. I couldn't coax her to turn around, so I drew her back. That's the print *Sally's Back.*

I found out later that Sally was pregnant when I was drawing her, which might account for her expression.

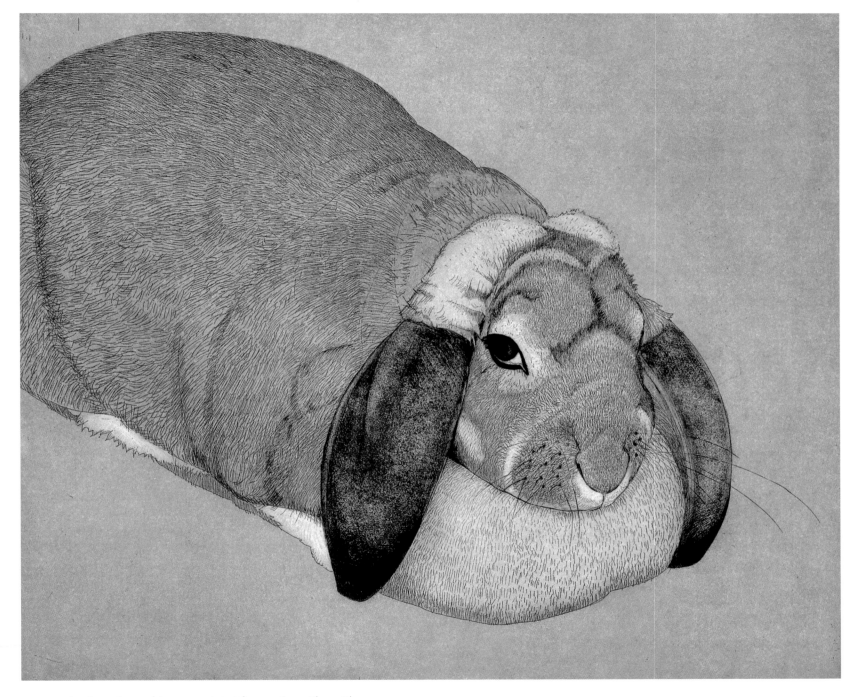

SALLY *1980, drypoint, etching, aquatint, à la poupée, 11½ × 13¾*

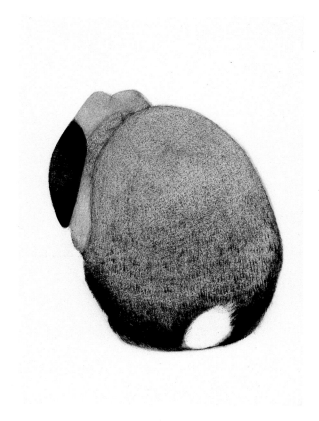

SALLY'S BACK *1980, drypoint, à la poupée, 6¹/₄ × 4¹/₂*

PARROT *1985, color pencil, 13 × 12*

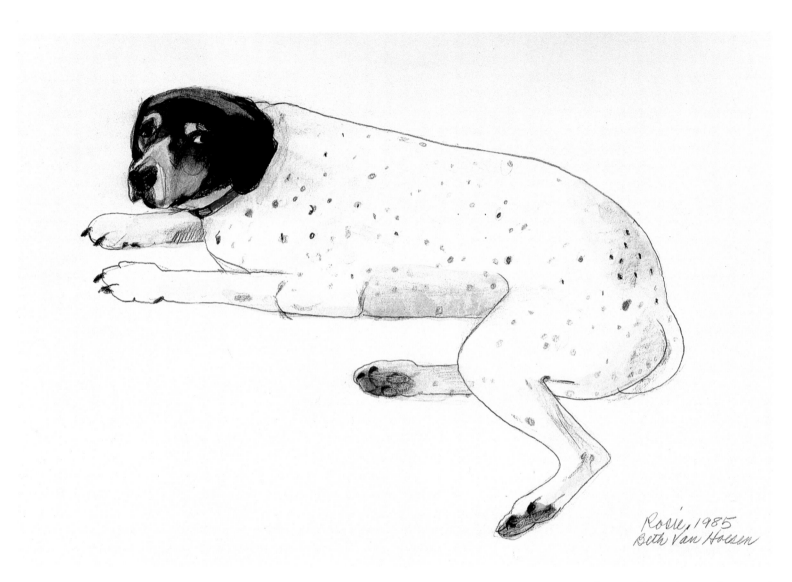

ROSIE *1985, watercolor, graphite, color pencil, 10 × 13½*

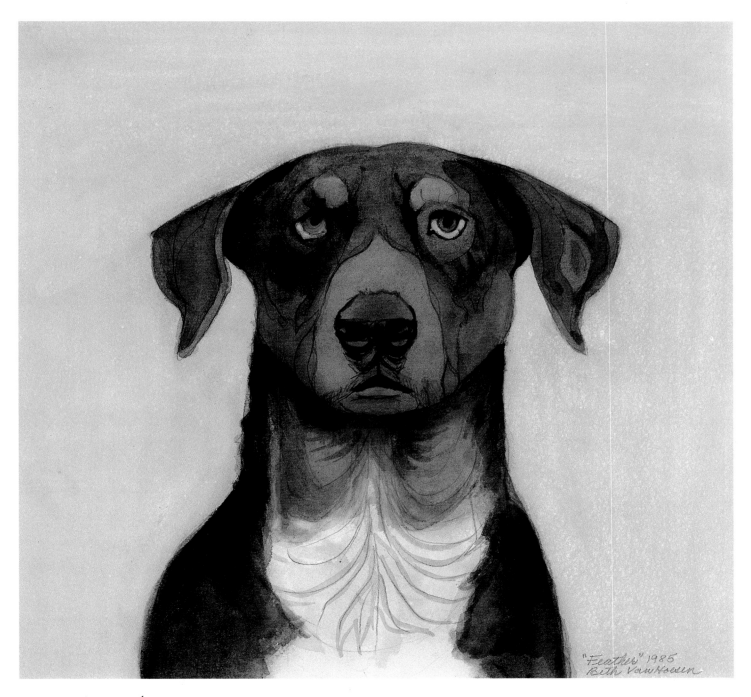

FEATHER *1985, watercolor, 14×15*

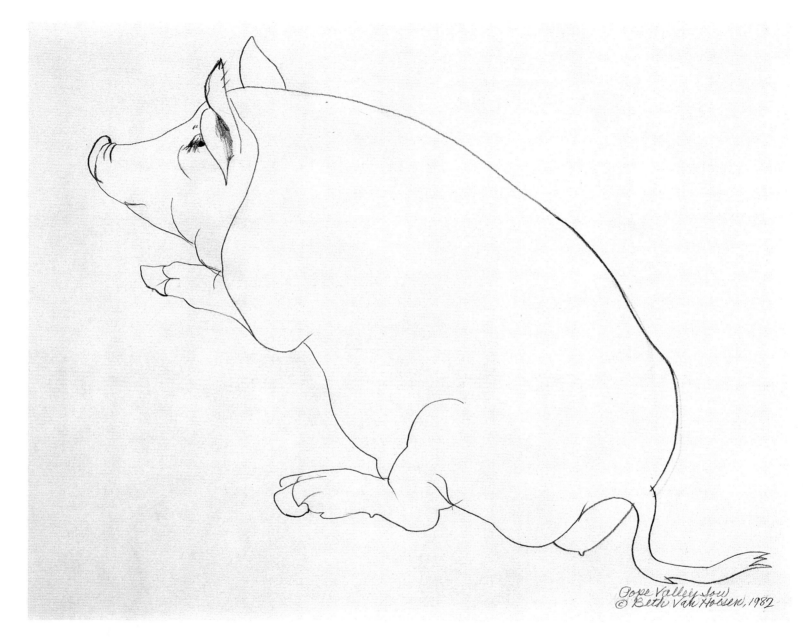

POPE VALLEY SOW *1982, graphite,* 14¼ × 17¾

More Pigs

As far as pigs were concerned, there were two things I had always wanted to draw. One was a huge, dirty hog; the other was a litter of piglets. We were in the country in the spring, and I thought there must be pig farms nearby. I couldn't find one in the yellow pages, so I called the local chamber of commerce. The woman there was very helpful and thought she remembered that a girl in the building had friends who had new piglets. She called the girl to the phone, and we got the telephone number of her friend.

We spent a long time on winding roads trying to find the little farm. The farmers were formerly city dwellers who had moved to the country. The wife raised a few goats, sheep, and pigs, which she sold for extra spending money. She showed us the pigpen, where a wonderful pile of piglets slept in a pink heap. I thought that this was just what I wanted to draw. They were enclosed in an area with an electric wire around it about a foot above the ground, so I could step over it and get quite close. When we approached, however, they all scattered. They never did go back together in a pile, so I drew them lying all over the place.

My printer says these little pigs remind him of cocktail sausages.

Hawkins

I finally found my old hog in the hills at a farm where I had gone to draw a Swiss bull. The hog's name was Hawkins, and he had arthritis. He shared his pen with an old sow named Jasmine.

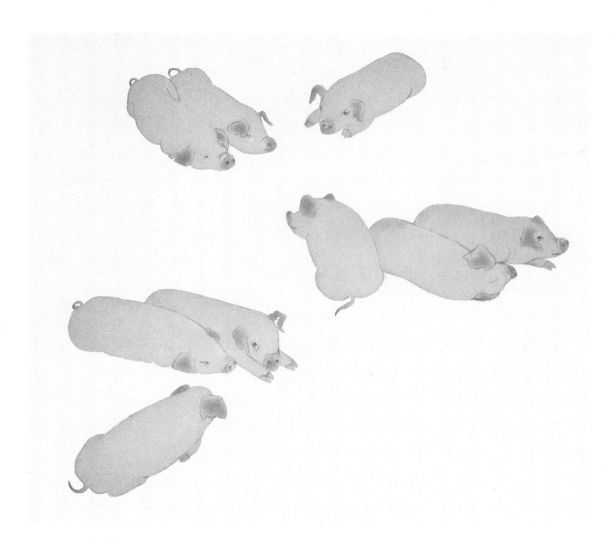

MORE PIGS *1983, drypoint, aquatint, 7½ × 8¼*

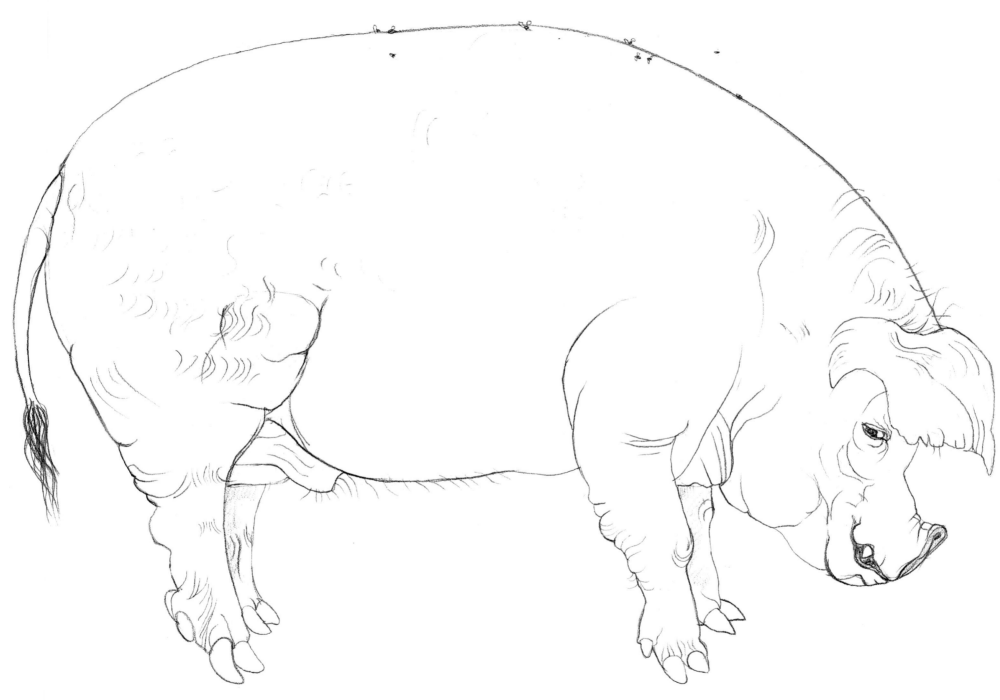

HAWKINS *1982, graphite, 14×16¾*

Brown Bear

Many years ago in Mesa, Idaho, my grandfather brought home an orphaned black bear cub for my cousin. He was given rides in a baby buggy, and even though he was very small, he climbed the high trellis over our gate.

Black bears climb trees when they are frightened by huge brown bears, knowing brown bears are too heavy to climb after them. It is difficult to distinguish bears by their color since black bears can also be cinnamon to pale brown, and bears called brown can be almost black to almost white. One can usually tell them apart by their size.

The brown bears I drew at the San Francisco zoo were Kodiaks. They sat holding their feet, looking at nothing in particular. Sometimes they slowly waddled, pigeon-toed, among the artificial rocks—or bit the stream of water from a hose.

I returned to draw the brown bears several times, but it wasn't until I studied their profiles that I began to feel their power. It was surprising to find in the finished print a sense of sadness I hadn't been aware of when I was drawing.

We tend to think that animals of a breed are all alike, yet in observing and drawing them, I have found each to be unique in appearance and temperament; and each, lacking any pretense, seems to have a natural dignity. It is unsettling to look into their eyes and wonder what they know. There is a great distance between us, yet we feel so much in common as creatures.

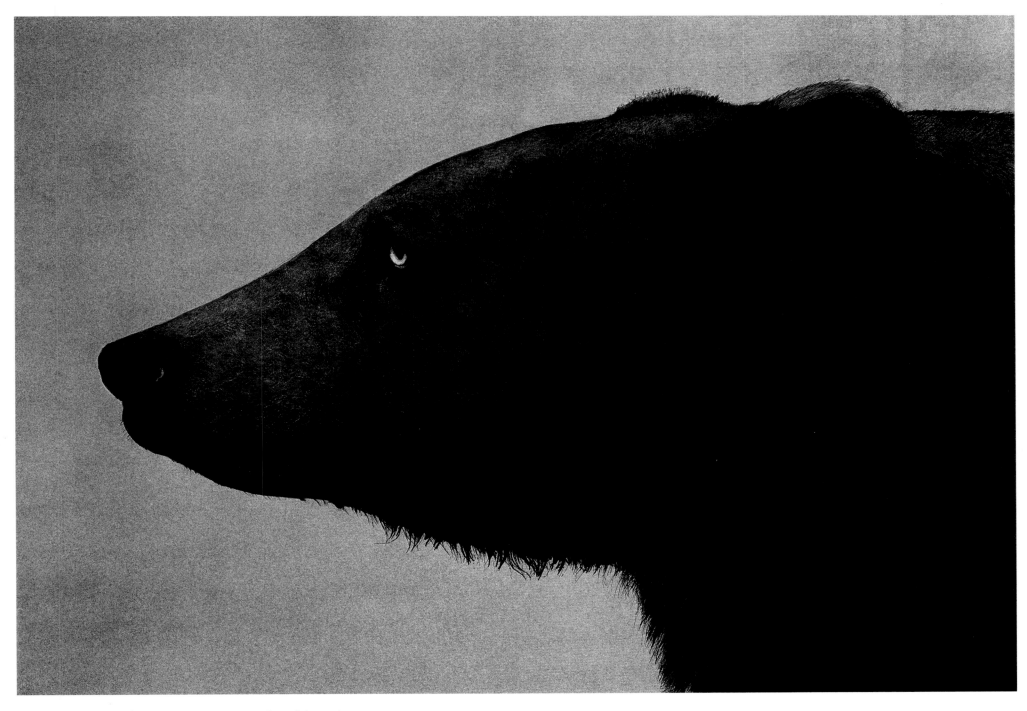

BROWN BEAR *1985, drypoint, aquatint, watercolor, 14¼×20¼*

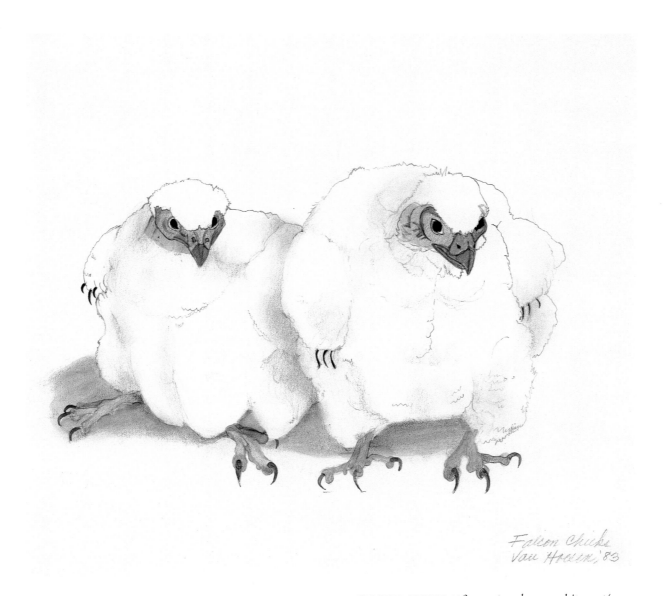

FALCON CHICKS *1983, watercolor, graphite, 10½×11*

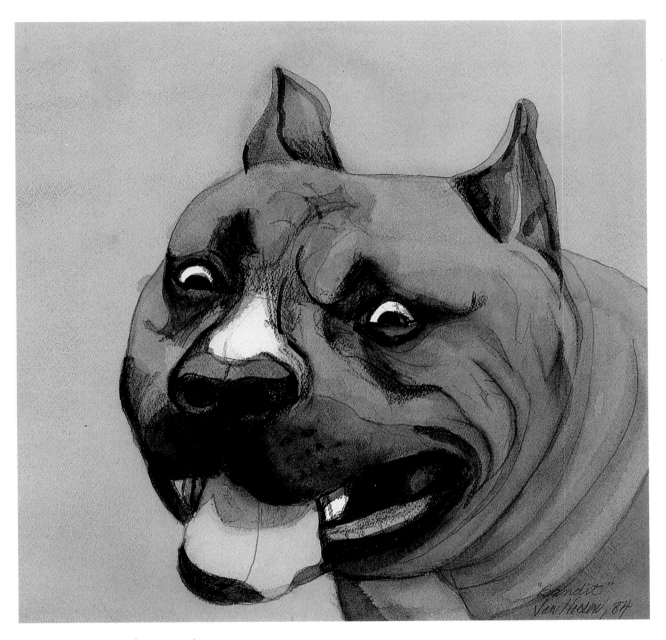

BANDIT *1984, watercolor, 13 × 13¼*

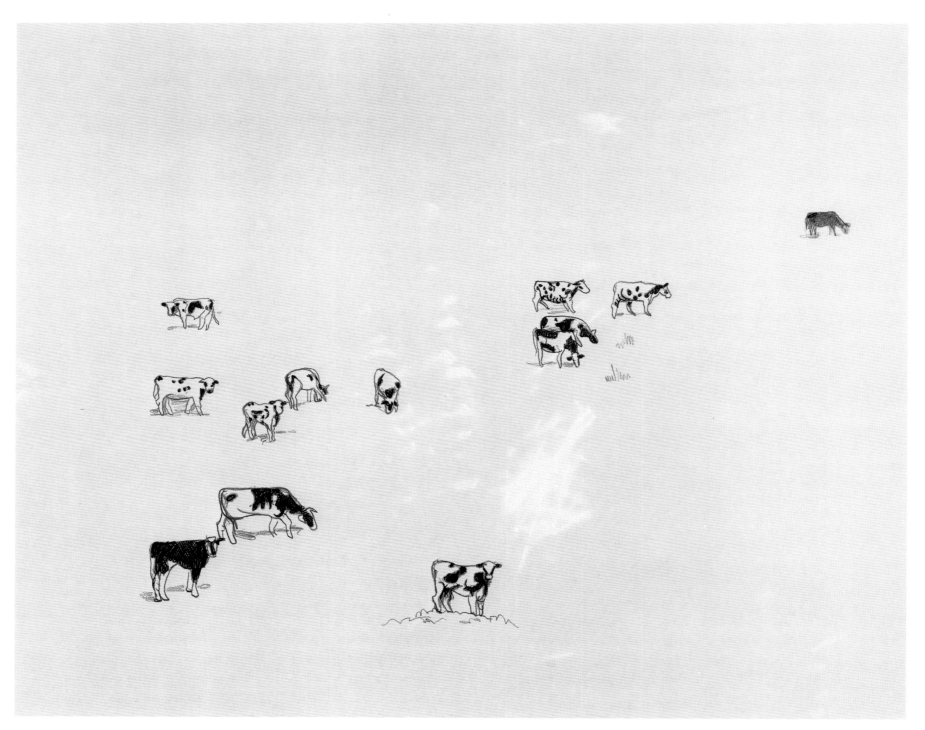

COWS IN FIELD *1982, graphite, ink, color pencil, 13½ × 16¾*

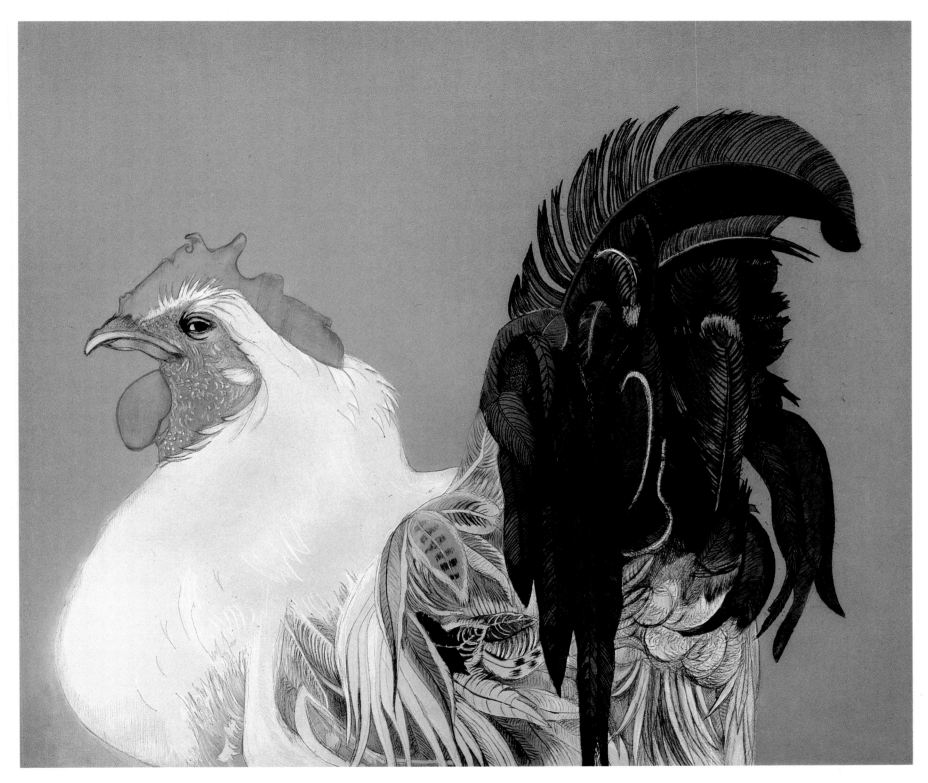

BORIS *1981, aquatint, drypoint, etching, watercolor, 15¼ × 17¾*

Making the Sally Print

Although I work in many mediums, drawing with an HB pencil is what I do most. Sometimes I work with a spontaneous line, making a dozen or more successive drawings to achieve a good one in which a single flowing line expresses the whole form (e.g., *Pig*). Other times, I use many lines to recreate the uniqueness of each feather (e.g., *Toulouse*). Those are the same approaches I use when drawing animals, people, flowers, vegetables—mostly God-made things. I try to capture their sense of life and individuality.

My interest in line drawings brought me to printmaking and especially to intaglio (pronounced in-TAHL-yo), a word that means cut below the surface. It includes engraving, drypoint, etching, and aquatint. These methods offer a great range of expressive line and tone qualities. When I search for subject matter, I think of which type of line will best express it.

One of my prints that uses several of the intaglio mediums is *Sally*, the French lop rabbit. In addition to line, it also includes texture, tone, and color. Following is a description of how it was developed.

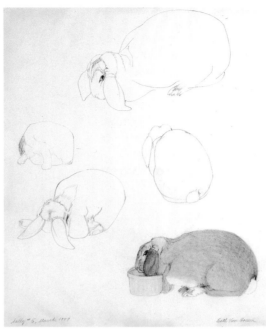

FIGURE 1

When I draw an animal, I sit quietly, studying its movements, watching for the attitudes and positions that are unique to the particular animal. I look for poses that may be held for some time or returned to frequently. Often the studies start with many line drawings—small full figures or details of heads, paws—those things I think I need to study to understand.

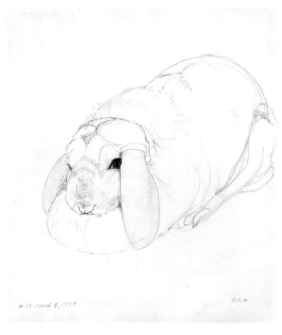

FIGURE 2

There may be as many as fifty drawings from one animal. In the case of *Sally*, there were twenty. This particular pose seems to capture the comfortable but wary sense of her, and I like the strong simple composition which is developing.

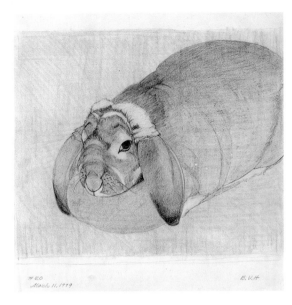

FIGURE 3

The next step is to develop the color. I want a combination of Sally's color, which will communicate the feeling of her, and a limited number of other colors that will make a strong print.

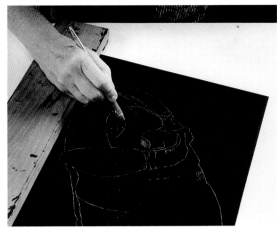

FIGURE 4

Using white transfer paper, the final drawing is traced onto a sheet of 1/16-inch polished copper that has been coated with an acid-resistant dark wax. The outlines of Sally are drawn through the wax to expose the copper. The hairs of the fur are done while looking at the live rabbit. The plate is then put into an acid bath of Dutch mordant, which attacks the exposed copper. When the acid has eaten a line to the desired depth, the plate is washed and dried and the wax ground removed with mineral spirits.

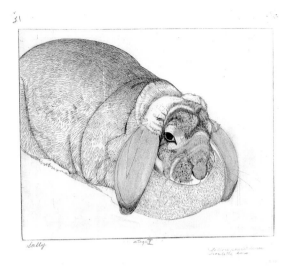

FIGURE 5

A black-brown printing ink is spread on the plate and worked into all the lines. The plate is wiped with tarlatan, a stiff netting, leaving ink in the lines, but only a slight film on the surface. The final wiping is done with the edge of the hand. Now I am ready to pull the first-stage proof.

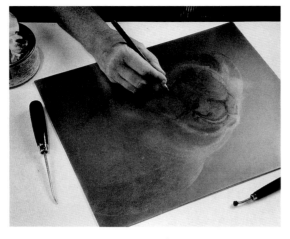

FIGURE 6

The eye and details of the face are strengthened by drypoint. Using a tool with a very sharp point (a diamond tip or ground steel), I draw small lines on the plate in such a way as to push up a ridge of copper on one edge of the line. Ink will collect behind the ridge when the plate is wiped for printing and produce a velvety black line. The ears are given a darker tone by using a roulette—a small cylinder of metal with sharp teeth that, when rolled on the plate, produces burrs of copper, which also hold the ink.

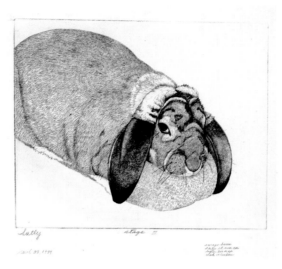

FIGURE 7

In this stage, the darkened details of the head and ears show clearly. There have been more hairs added to the fur. Some long lines over the shoulder have been scraped out. At this point, I feel ready to proceed with the aquatint. Fine ground rosin dust is settled evenly on the plate and heated to the melting point so it adheres to the copper. Stop-out varnish is applied to any area that does not have tone—in this case, only the white of Sally's eye. Then a slow acid bath will bite around each bit of rosin. This will produce an even tone.

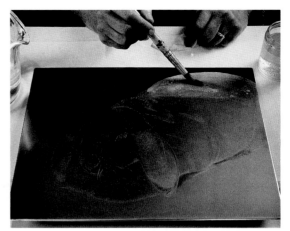

FIGURE 8

When the overall tone of this aquatint is deep enough, the plate is rinsed and carefully dried. Because I want to gently darken the top of Sally's back, I block out the background above her with asphaltum, a heavy-duty acid-resistant coating. Then with brush, gum arabic, and water, I put a graduated wash of nitric acid on the upper back, strong near the edge, diluting to clear water in the center of the body. Where the acid is strongest, it bubbles and turns green. After the plate is cleaned, I will lighten the aquatint tone on the ruff, chest, and top of the head by using a burnisher (Figure 6, foreground) to smooth down the areas that need to be lightened.

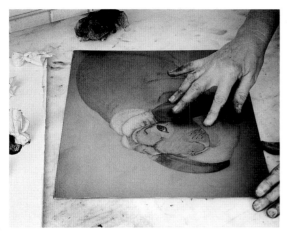

FIGURE 9

It is time to take another proof—this time in color. Instead of a separate plate for each color, all of the colors are put on one plate, using either fingertips or little daubers of rag tied like dolls. This is called inking *à la poupée* (*poupée* is French for doll). First the whole plate is inked and wiped in the basic color; then areas such as the ruff, the chest, the eye, and the ears are wiped clean with a cloth.

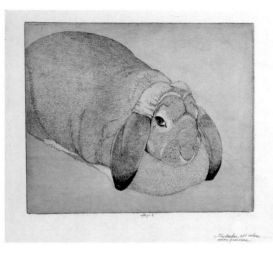

FIGURE 10

Black is rubbed into the eyes and ears and carefully wiped. The rust color of the ruff is gently blended back into the main body color (*à la poupée* blend), and the yellow ochre of the chest is done the same way. All of the colored inks are now in the lines or aquatint, and the surface is wiped clean.

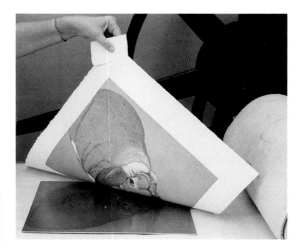

FIGURE 11

The inked plate is put face up on the press bed and covered with a piece of dampened paper. Felt blankets are placed over it, and it is rolled through the press. The pressure squeezes the paper into the lines and aquatint, where it picks up the ink. The pressure also creates the plate mark (the raised margin around the edge of a printed image), which identifies it as an intaglio print. I lift the blankets back slowly and raise the paper, and, *voilà*, the image appears.

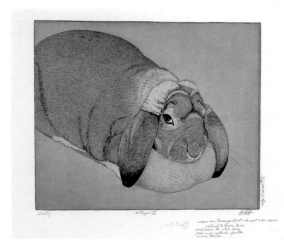

FIGURE 12

More work is done with the burnisher and scraper until the print is just the way I want it. Often as many as a dozen stage proofs are pulled as I continue to perfect the plate.

The first good print is called a BAT—*bon à tirer*, or good to pull. This is the print I will sign and give to a professional fine arts printer, who will then match the ink and wipe the plate so the print duplicates my BAT. When his print matches mine, he will begin to print the edition.

Often when I use very fine aquatints in my prints, I work with a professional printer who understands what I want and knows how to do it. Timothy Berry (Teaberry Press) and I have worked together for about six years. Many of the prints in this collection are the result of our collaboration. The artist/printer relationship historically has brought together two aspects of expertise to solve the unique problems inherent in printmaking.

If the edition of prints is to be a large one (seventy-five to one hundred), the plate will be steel faced. The copper is covered by a micro-scopically thin layer of iron in an electroplating bath. Because iron is harder than copper, it reinforces the delicate marks on the plate against the wear involved in printing the edition.

Each print takes about half an hour to ink, wipe, and print. The paper I use is BFK Rives, a rag paper that will not discolor with age. When the edition is finished and the ink is dry, the printer will put his embossed mark, called a chop, in the lower corner of each print and bring them to me to number and sign.

If the numbering starts with 1/50, that means it is the first print in an edition of fifty prints. It does not speak of differing qualities of sequence since the order is often mixed by the printer. It is standard procedure to have extra prints, equal in number to 10 percent of the edition, which are called artist proofs and numbered with "AP." These belong to the artist. Before signing, the artist reviews each print for errors. His signature indicates his acceptance.

Acknowledgments

I would like to thank some special people who have helped me with this book.

My husband, Mark Adams, searched with me through hundreds of drawings and prints to choose from among them, then spent long hours setting up the sequence and positioning the work for the book.

Jan MacDonald, our assistant, archivist, and girl Monday, helped with every phase of the work, using her sensitive eye and keeping the work—and me—in order.

Carolyn and James Robertson of The Yolla Bolly Press believed that my animals would make a good book, then helped make it happen.

And to all the owners and keepers who shared their animals with me, I offer my special appreciation.

The following printers worked with me on prints in this book. Crown Point Press: Gwen Gugell; El Dorado Press: Jean Ganz, David Kelso; Katherine Lincoln Press: Kay Bradner; made in california: David Kelso; Hirsh-Greene: Anne Hirsch, Scott Greene; Trillium: David Salgado, Terry Rein, Tom Goglio; Teaberry Press: Timothy Berry; Robert Townsend, Boston.

Printers who worked on the press in my studio: Jennifer Cole, Mark Johnson.

Biography

Beth Van Hoesen was born in Boise, Idaho, in 1926. She attended the following schools: Stanford University, 1944–48, B.A.; Escuela Esmeralda, Mexico, 1945; California School of Fine Arts, 1946, 1947, 1951, 1953; École des Beaux Arts de Fontainebleau, France, 1948; Académie Julian and Académie de Grande Chaumière, Paris, 1948–50; San Francisco State College, 1957, 1958.

She married artist Mark Adams in 1953. They live in a converted 1909 firehouse in San Francisco, California.

SELECTED SOLO EXHIBITIONS

Lucien Labaudt Art Gallery, San Francisco, California, 1952
Stanford University Art Gallery, Stanford, California, 1957, 1983
M. H. de Young Memorial Museum, San Francisco, California, 1959
California Palace of the Legion of Honor, Achenbach Foundation for Graphic Arts, San Francisco, 1961: *Beth Van Hoesen* (catalogue); 1962: traveling to Boise Gallery of Art, Idaho; Santa Barbara Museum of Art, California; IBM Corp., San Jose, California; 1974: *Beth Van Hoesen* (catalogue)
San Francisco Museum of Modern Art, California, 1965

Felix Landau Gallery, Los Angeles, California, 1966
E. B. Crocker Art Gallery, Sacramento, California, 1966
Hansen-Fuller Gallery (later Fuller-Goldeen), San Francisco, California, 1966, 1977, 1980
San Diego State University, California, 1967: *The Eloquence of the Line, Prints by Beth Van Hoesen*
Walnut Creek Civic Arts Gallery, California, 1969
Fountain Gallery, Portland, Oregon, 1965, 1970, 1983
Smith Anderson Gallery, Palo Alto, California, 1971, 1974
University of Idaho, Moscow, 1973
College of Idaho, Jewett Exhibition Center, Caldwell, 1973
Contemporary Graphics Center of the Santa Barbara Museum of Art, California, 1974
Young Gallery, San Jose (later Saratoga), California, 1979, 1981, 1983, 1986
Oakland Museum, California, 1980: *Beth Van Hoesen—Prints, Drawings, Watercolors* (catalogue)
John Berggruen Gallery, San Francisco, California, 1982 (catalogue), 1985
Art Museum Association of America, traveling exhibition, 1983–85: *Beth Van Hoesen: Prints, Drawings, Paintings* (catalogue); traveling to de Saisset Museum, University of Santa Clara, California; El Paso Art Museum, Texas; Fresno Arts Center and Museum, California; Kaiser Center, Oakland,

California; North Dakota State University, Fargo; The Haggin Museum, Stockton, California; Scottsdale Center for the Arts, Arizona; Boehm Art Gallery, Palomar College, San Marcos, California; Kittredge Gallery, University of Puget Sound, Tacoma, Washington; Missouri Botanical Garden, St. Louis

Arizona State University Art Collections, Tempe, 1984: *Wonderful Animals of Beth Van Hoesen*

SELECTED GROUP EXHIBITIONS

California State Fair Exhibition, Sacramento, 1951 (award), 1952, 1958, 1959, 1960, 1961

Library of Congress, Washington, D.C., 1956, 1957

San Francisco Museum of Modern Art, California, 1951; 1952; 1953; 1954; 1956 (award); 1957; 1958; 1959 (award); 1960; 1961 (award); 1962; 1964; 1965; 1967; 1970 (award); 1985; 1986: *Moses Lasky Collection*; 1986: *American Realism: Twentieth-Century Drawings and Watercolors* (catalogue)

California Palace of the Legion of Honor, Achenbach Foundation for Graphic Arts, San Francisco, 1951, 1958, 1959, 1960, 1961 (award), 1964, 1965 (award), 1966, 1976, 1977, 1979, 1981, 1983

Oakland Museum, California, 1958, 1960, 1974 (award), 1975 (award)

American Federation of Arts, traveling exhibition, 1963: *Some Images of Women*

U.S. State Department, Art in Embassies, 1966–68

Honolulu Academy of Arts, Hawaii, 1959, 1970, 1971 (award), 1973, 1975, 1980 (award)

Museum of Fine Arts, Boston, Massachusetts, 1959, 1960, 1962

Pennsylvania Academy of Fine Arts, Philadelphia, 1959, 1960, 1963, 1965

Northwest Printmakers International Exhibitions, Seattle Art Museum, Washington; Portland Art Museum, Oregon, 1962, 1963

Brooklyn Museum, New York, 1962; 1965: *Amerikanische Radierungen*, traveling through Germany, sponsored by Brooklyn Museum; 1966; 1968; 1977

M. H. de Young Memorial Museum, San Francisco, California, 1956, 1963, 1964

Pasadena Art Museum, California, 1964 (purchase award)

Norfolk Museum of Arts & Sciences, Virginia, 1965, 1970

World Exposition, Osaka, Japan, 1970

Van Straaten Gallery, Chicago, Illinois, 1974

Fine Arts Gallery of San Diego, California, 1967, 1971, 1977

Impressions Workshop, Boston, Massachusetts, 1977: *West Coast Prints*

Smith-Anderson Gallery, Palo Alto, California, 1977: Adams, Cook, Van Hoesen: *Works on Paper*

Mills College Art Gallery, Oakland, California, 1978, 1983

Pratt Manhattan Center Gallery, New York, New York, 1980

University of Massachusetts, Amherst, 1980

Tahir Gallery, New Orleans, Louisiana, 1981, 1986

Susan Blanchard Gallery, New York, New York, 1983

Charles Campbell Gallery, San Francisco, California, 1983: *Five San Francisco Artists*; 1986: *Life Drawing—1980s: Seven San Francisco Artists* (catalogues)

Corpus Christi State University, Texas, 1983: *Creatures in Print*

Port of History Museum, Philadelphia, Pennsylvania, 1983: *Printed by Women*

The Print Club, Philadelphia, Pennsylvania, 1983: *Choice Prints*

Modernism Gallery, San Francisco, California, 1984: *California Drawings*

Portland Art Museum, Oregon, 1985

World Print Council, traveling exhibition, 1984–86: *Prints U.S.A.* (catalogue)

Transamerica Pyramid, San Francisco, California, 1985: *A City Collects*

University of Tennessee, Chattanooga, 1985: *Two California Artists: Mark Adams/Beth Van Hoesen*; traveling to LaGrange College, Georgia

BOOK

A Collection of Wonderful Things, Intaglio Prints by Beth Van Hoesen, Scrimshaw Press, San Francisco, California, 1972

SPECIAL AWARD

City of San Francisco, *Award of Honor in Graphics*, 1981

SELECTED PUBLIC COLLECTIONS

Achenbach Foundation for Graphic Arts, San Francisco, California

Brooklyn Museum, New York

Chicago Art Institute, Illinois

Cincinnati Art Museum, Ohio

de Saisset Museum, University of Santa Clara, California

El Paso Museum, Texas

Fresno Arts Center and Museum, California

Honolulu Academy of Arts, Hawaii

Mills College, Oakland, California

Museum of Modern Art, New York City

Norton Simon Museum, Pasadena, California

Oakland Museum, California

Portland Art Museum, Oregon

City and county of San Francisco, California

San Francisco Museum of Modern Art, California

San Jose Museum of Art, California

Santa Barbara Museum of Art, California

Stanford University, Stanford, California

Smithsonian Institution, Washington, D.C.

U.S. Information Bureau, Washington, D.C.

University of California, Berkeley

University of California, Davis

University of Idaho, Moscow

University of Tennessee at Chattanooga

Victoria and Albert Museum, London, England

Williams College, Williamstown, Massachusetts